BK 745.619 L185C
CHINESE CALLIGRAPHY : AN INTRODUCTION
/LAI, TIEN-
C1973 10.00 FV

D1269510

) 381806 30017
ımunity College

FV

745.619 L185c
LAI
 CHINESE CALLIGRAPHY: AN INTRO-
DUCTION
 10.00

WITHDRAWN

JUNIOR COLLEGE DISTRICT
of St. Louis - St. Louis County
LIBRARY
5801 Wilson Ave.
St. Louis, Missouri 63110

CHINESE CALLIGRAPHY

An Introduction

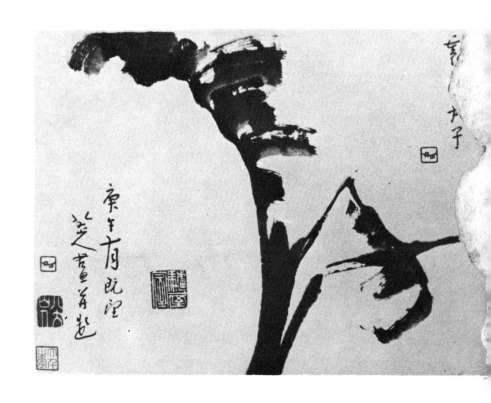

Chinese Calligraphy

An Introduction

T. C. LAI

Introduction by Jiu-fong L. Chang

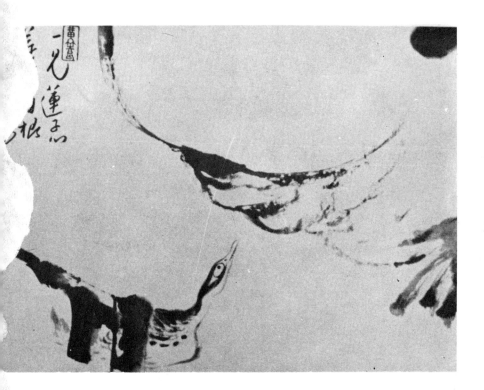

UNIVERSITY OF WASHINGTON PRESS • SEATTLE AND LONDON

Copyright © 1973 by T. C. Lai
Introduction by Jiu-fong L. Chang copyright © 1975 by the University of
Washington Press
First published in 1974 by the Swindon Book Company, Kowloon, Hong
Kong, with the title *Chinese Calligraphy: Its Mystic Beauty*
University of Washington Press edition first published in 1975
Printed in the United States of America

All rights reserved. No part of this publication may be reproduced or trans-
mitted in any form or by any means, electronic or mechanical, including pho-
tocopy, recording, or any information storage or retrieval system, without
permission in writing from the publisher.

Library of Congress Cataloging in Publication Data

Lai, T'ien-ch'ang.
 Chinese calligraphy.

 Bibliography: p.
 1. Calligraphy, Chinese. I. Title.
NK3634.A2L34 1975 745.6'199'51 74-31264
ISBN 0-295-95340-3
ISBN 0-295-95381-0 pbk.

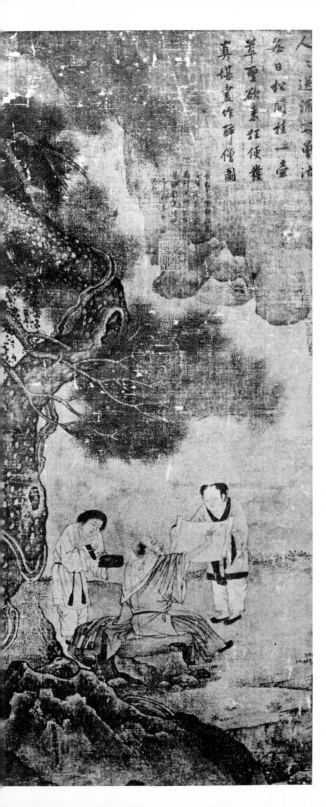

CONTENTS

ACKNOWLEDGEMENTS

Grateful thanks to:

Mr. S.P. Chang for his advice and help in romanizing proper names and for the use of Shen Yin Mo's calligraphy reproduced on p. 215.

Dr. A.R.B. Etherton for valuable suggestions

Mr. William Hung for a photographic copy of Li Po's calligraphy reproduced on pp. 100-1.

Mr. Chan Fan and Mr. Charles Wong for generous assistance.

Mr. Henry Lee for suggesting the subtitle "Its Mystic Beauty".

The Library of the Chinese University of Hongkong, and

The Art Gallery of the Centre for Chinese Studies for various courtesies.

Mrs. Maranda Yeung for compiling the Glossary and general assistance rendered.

Credits

The Art Museum, Princeton University for calligraphy of Ch'en Hung-shou on page 169.

Ip Yee collection for calligraphy on p. 209

Wango H.C. Weng collection, New York, for Hsü Wei's calligraphy on page 164.

V.C. Kuo collection for calligraphy on page 171.

K.F. Lee collection for calligraphy on p. 165

Shoso-in, Nara for calligraphy on page 219.

Daitoku-ji, Kyoto for calligraphy of Ikkyu Sojun on page 228.

Collection of Ryoyi Kuroda, Kanagawa Prefecture for calligraphy on page 232.

Shisen-do, Kyoto for calligraphy by Ikeno Taiga on page 231.

Yomei Bunko Library, Kyoto for calligraphy attributed to Emperor Saga on page 223.

Shoso-in, Nara, for calligraphy on page 222.

Critical remarks quoted are acknowledged as follows:

Chiang — for Chiang Yee's CHINESE CALLIGRAPHY (Harvard, 1973 pp. xx250)

Ch'en — for Ch'en Chih-mai's CHINESE CALLIGRAPHERS AND THEIR ART (Melbourne 1966 pp. xx286)

Tseng — for Tseng Yu-ho Ecke's CHINESE CALLIGRAPHY (Philadelphia 1970)

FOREWORD

Chinese calligraphy is a fine art, one which enjoys a status as high, if not higher, than painting. Because of its subtle and abstract qualities, it confounds not only Westerners but also the Chinese themselves.

Beauty in Chinese calligraphy is difficult to define; neither is it easy to tell why certain pieces are more beautiful than others. The main purpose of this book is to provide a good number of specimens so that by looking at them the beginner will be able to grasp the aesthetics of the art. However, the ability to tell the difference between mediocrity and excellence can only be acquired by frequent exposure to great works, or better still, by practising the art.

Some calligraphers were also painters. I have placed their paintings side by side with their calligraphy to show how the two skills were related in spirit and technique. This volume is conceived primarily as a collection of specimens arranged chronologically. However some historical, biographical and critical notes are given, which should prove helpful.

Chinese University of Hongkong
November 1973 T.C. Lai

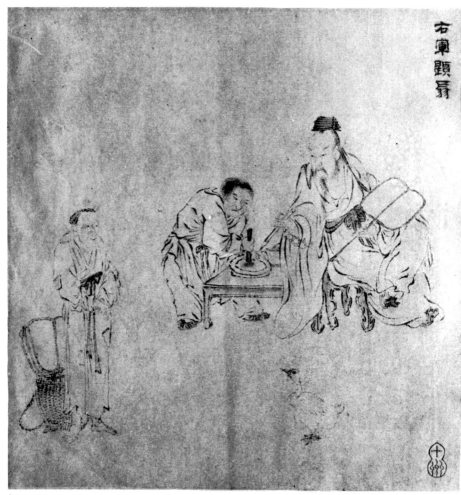

Wang Hsi Chih inscribing a fan for an old woman in exchange for a swan
Ch'iu Ying c. 1500-1550

INTRODUCTION

Chinese calligraphy is an art with an illustrious tradition as old as the culture itself. For nearly two thousand years, the basic media, the major script variations, and the standards of excellence of the art have remained almost unchanged. The volume of masterpieces and critical scholarship, preserved and accumulated through the ages, truly staggers the imagination. Calligraphy may also be regarded as a precursor and a companion of the art of painting in China. While the techniques of handling the brush in executing the various scripts constitute basic training for every painter, the pure abstract vision of calligraphy is also clearly reflected in the expression of subjective mood and impulse through abbreviated images in painting. Perhaps more than any other visual art, calligraphy can best reveal the Chinese mind and represent its aesthetic ideal.

On the practical level, the application of calligraphy in the life of the Chinese is broad and diverse. As early as the Han dynasty (202 B.C.–A.D. 220), the commissioning of expert calligraphers to transcribe epitaphs and of master craftsmen to engrave them on stone was already a widespread custom. To this day, most Chinese prefer vertical markers with appropriately written and engraved inscriptions for the graves of their deceased. All over the country, historical and scenic sites display indelible calligraphic markings on gates and archways, cliffs and stone tablets, inscribed with a word or phrase in eulogy, a poem or narrative in commemoration, sometimes in the hand of very famous personages of the past. During lunar New Year celebrations, the ubiquitous red-paper squares and strips bearing auspicious words and couplets and pasted on doorways lend much to the air of festivity.

The social position traditionally enjoyed by the prominent calligrapher in China has few parallels in other societies. Since he normally comes from among scholars, poets, artists, officials, and men and women of letters and independent means, there is usually no need to sell his work. Rather, he is glad to "flourish his brush" for any admirer who brings him the paper and sometimes a gift. His calligraphy can be seen and appreciated on shop signs, book covers, and on walls in private homes and public buildings. For weddings, birthdays, and funerals, felicitations or condolences often take the form of an appropriate saying, a poem, or a pair of rhyming lines, specially chosen and elegantly transcribed and

mounted for the occasion. A painter whose own calligraphy does not measure up to his art often seeks a prominent calligrapher's inscription on his work, thus enhancing its style and artistic worth. In fact, ever since the Sung dynasty (960-1279), no painting could be considered complete without a corresponding inscription and the artist's personal seal or seals, the designing and engraving of which is an art also closely allied to calligraphy. Connoisseurship in calligraphy is a discipline on a par with connoisseurship in painting and other arts.

Even in this age of the typewriter and ballpoint pen, and the movement toward drastic reform of the language, calligraphy is not entirely a thing of the past. It commands a loyal following in Taiwan, in Japan, and in other places where Chinese reside, both as a serious artistic pursuit, and as a recreational medium for the retired and those seeking relaxation from the tensions of modern life. A number of successful exhibitions of Chinese calligraphy have recently been held in the United States and Europe, and certain groups in the Western art world, such as the Abstract Expressionists and the West Coast artists, have shown marked affinity with the idea of the spontaneous expression of lines and shapes which is precisely the essence of beauty in calligraphy.

What, then, is the historical genesis of this art, which is neither graphic nor representational, and wherein lies its enduring aesthetic foundation?

The answers have to be sought in the nature and development of the Chinese language. From archeological evidence dating back more than four thousand years, it appears that pictographic symbols were devised to represent objects, natural phenomena, and concepts. As these picture writings became more abstract and stylized, a greater number of ideographic symbols came into being through the combination of two basic elements drawn from the existing vocabulary. In some cases both components contribute to the idea; more frequently, one part is the signific (the radical) and the other is the phonetic. As the culture grew in complexity, other characters were added through the processes of semantic extension and borrowing. The result was a rich corpus of more than fifty thousand characters, each consisting of one to some thirty separate strokes and bounded by the sides of an imaginary square. Every character is thus an imagistic representation with a distinct personality, notwithstanding its many stylistic variations and abbreviated forms.

The devising of scripts for the Chinese language was from the beginning an artistic as well as a utilitarian endeavor. Legend has it

that Ts'ang Chieh observed the patterns and movements of the celestial bodies and earthly creatures before creating the earliest writing system. Some of the scripts long since extinct bore such descriptive names as "tadpole script," "bird script," and "tiger script." Standardization of the language was brought about during the third century B.C. under China's first unifier, Ch'in Shih Huang Ti, and since then it has continued to develop along evolutionary lines, without marked influences from the intermittent political turmoil and foreign invasions.

Evidence on neolithic pottery and on oracle bone and shell remains indicates that the forerunner of the writing brush was in use very early, although incisions on the hard surfaces were made by sharp pointed instruments. Later, brush and black ink were used to write on silk and on wooden and bamboo slips which were tied together at one end to form the earliest books. The beginning of true brush calligraphy, however, had to wait until the second century A.D., when paper was invented. Intense activity in this art led to the blossoming of many new scripts within two centuries. Many outstanding specimens of works by known and unknown calligraphers have been preserved through the fine arts of stone-engraving and ink rubbing, which made reproduction and dissemination possible during succeeding ages.

It was also during the Han dynasty that Confucianism was established as the official orthodoxy of the nation, and its rigorous system of education included calligraphy as a basic skill to be taught from early childhood. The student not only had to learn to write correctly and well, but also studied and emulated the works of the famed masters of the past in a variety of scripts and styles. A good hand was a prerequisite to success in civil-service examinations and in government employment. Distinction in the art was possible only after years of assiduous study and diligent practice, which were also considered contributory to character building. A man's calligraphic style inevitably reflects his personality, and anecdotes from the lives of famous calligraphers are legion.

Imperial patronage of calligraphy was exemplified by Emperor T'ai-tsung of the T'ang dynasty (618-906), who ordered a nationwide search for letters and manuscripts of his favorite calligrapher, Wang Hsi-chih (307-365), and had them edited and engraved as models for study. This tradition was carried on by many emperors after him: some were themselves accomplished calligraphers, and one, Hui-tsung of the Sung dynasty, originated a style which he named "slender gold" (see pp. 130-31).

The basic media of calligraphy, also known as the "Four Treas-

ures of the Scholar's Studio," were relatively simple from the outset and have remained substantially the same. The brush-pen consists of a bamboo or wooden stem and a pointed tuft made from the hairs of deer, sheep, weasel, rabbit, or wolf. Fine craftsmanship is required for the selection, arrangement, and tying of different hairs into varying lengths and thicknesses for a variety of purposes. The ink stick is made from a mixture of soot and animal glue which, when freshly ground with water on a fine ink palette, produces a smooth, creamy, black ink. The quality of the ink stick and the type of stone used for the ink palette are both important to the desired result, and no modern substitute such as bottled ink or prepared ink pads has proven entirely satisfactory. The final ingredient is the paper, which can have a variety of textures and finishes and is commonly made from mulberry bark, hemp fiber, or bamboo pulp. It can be made in a number of off-white shades and is sometimes imprinted with designs, decorated with gold speckles, or mellowed through aging.

The proper choice of the type and stiffness of the brush, the luster and thickness of the ink, the texture and absorbency of the paper, and the techniques of executing the various strokes in the different scripts are the subjects of numerous manuals and treatises written by experts through the ages. Since each move of the brush is final and irretraceable, the combination of intuition with discipline, erudition, and skill is essential. Eclecticism and archaism, as in other aspects of Chinese art and life, are both acknowledged principles in the calligrapher's creed, in which experimentation for its own sake has no place. His highest goal is the attainment of creative insight into the heritage of the past and achievement of virtuosity in an individualized style.

There are five major categories of calligraphic scripts, a survey of which will further illustrate the growth of the language and the art of calligraphy.

1. The Archaic Scripts include, in chronological order, the Oracle Bone Script, the Ku Wen or Ancient Script, the Ta Chuan or Large Seal Script, and the Hsiao Chuan or Small Seal Script, which together span a period of some two thousand years. Of around two thousand characters in the Oracle Bone Script (see pp. 4-5) that survived, a little more than half have been deciphered. Vividly suggestive of form and motion, these primitive symbols are irregular in size, structure, and line arrangement. The Ancient Script (see pp. 6-9) is found mostly in engravings inside bronze vessels which were also richly decorated with pictographic motifs. The close relationship

between writing and picture making was still very much in evidence in this script.

The Large Seal Script (pp. 10-17) was the product of further structural synthesis during the latter part of the Chow dynasty (1122-222 B.C.) when characters increased in both number and sophistication. Inscriptions preserved on stone show lines of equal thickness and characters of fairly uniform size. This bold and elegant script was the one in which the Confucian classics were originally written.

The Small Seal Script (pp. 18-21) was the standardized script promulgated during the Ch'in dynasty (221-207 B.C.). It was based on the many regional variants of the Large Seal Script and contained nearly ten thousand characters upon which all later scripts were built. The lines and structure of the characters were further streamlined and regularized. Many artists and calligraphers of later ages have continued to use this script for its balance and beauty in design, particularly in the art of seal engraving.

2. The Li Shu or Official Script (pp. 38-44) began as a simplified version of the Small Seal Script for use in government records and on stone monuments. It came into its own during the Later Han dynasty (A.D. 25-220) when the instruments of writing had been considerably refined. The ink rubbings from this period mark the dramatic emergence of brush calligraphy as a conscious and independent form of art. This script allows full play of the resilient brush, replacing the curves and circles of the Small Seal Script with supple straight lines and angular turns. Its air of ernestness and decorum has made it particularly fitting for use on tablets and monuments intended for posterity.

3. Ts'ao Shu or Cursive Script (pp. 45, 59, 103, 105-9, 116, 125, 151, 164-66, 169, 192, 213) was originally developed as a quicker version of the Official Script during the second century A.D. It is a sketchy script which can be executed with considerable speed and freedom, and it soon became a favorite vehicle for artistic expression. The characters do not conform to a grid and may be visibly or invisibly linked to one another as the brush moves down the line in a flourish. Abbreviations and distortions are common, resulting in effects that are startling and fresh, but often difficult for the untrained eye to decipher. Since this script offers the greatest amount of freedom for individual expression and improvisation, it is also the most controversial among critics and practitioners.

4. K'ai Shu or Regular Script (pp. 46-49, 55, 58, 63, 78, 81, 84, 88, 90-93, 95-96, 98, 110-11, 115, 141, 145, 153, 176, 188,

202, 205-8, 211), which is also descended from the Official Script, reached its apex during the T'ang dynasty when a number of calligraphers distinguished themselves in this medium. It is characterized by evenness and controlled execution of the strokes, greater rigidity in composition, and a more slender appearance in comparison with its progenitor. Because of its clarity and more limited range of variability, it has remained the standard script for formal purposes and is the first course of study for all beginners.

5. Hsing Shu or Running Script (pp. 51-54, 56, 82, 85, 86, 89, 97, 99, 112-14, 117-20, 122-24, 127, 129, 132-33, 135-38, 140, 142-44, 146-47, 150, 154, 163, 167-68, 172-76, 182-83, 185-86, 189-91, 193, 196, 198, 200-1, 203-4, 209, 210, 214-16) is a variation of the Official Script which developed alongside the Regular Script during the same period. It is distinguishable by ease of brush movement, some modification of character structure, and the absence of rigid angularity. It was already popular during the time of the great calligrapher Wang Hsi-chih, but the pinnacle of achievement was reached during the Sung dynasty when emperors, poets, artists, and monks vied with one another in pursuit of this art. For the well-trained calligrapher, the Running Script allows innovative use of the brush and ink and individualized expression through variations in his vision and technique.

Of the five major categories, the Archaic and Official scripts are less commonly used today except for special decorative purposes or antiquarian interest. The Cursive, Regular, and Running scripts, on the other hand, have flourished side by side up to the present time, and numerous calligraphers have added their particular contributions, often in more than one script. To the modern aspirant, the weight of tradition is not considered a burden, but rather an honored heritage from which new heights may be scaled.

In this respect, the position of calligraphy as a fine art for the Chinese has many parallels with that of classical music for the contemporary West. Both play a basic role in the education of the young and the cultivation of the higher intellect, and each requires systematic training in all the syles of the past and a serious commitment to the tradition of the art. The calligrapher is much like the musician who is able to perform compositions in many styles, yet whose temperament and special talent are usually best suited to one or two composers or periods. Collectors and connoisseurs of calligraphy are much akin to music lovers who will not tire of repeatedly hearing the same piece of music played by the same artist but also enjoy listening to pieces from different periods performed by different artists.

The essence of Chinese calligraphy, in sum, is the dynamic force in the execution of the line, with its infinite range of rhythmic permutations and combinations. The construction of the character, according to one critic, is guided by a series of opposites: "forward and backward," "confronting and backing away," "rising and falling," "light and heavy," "condensed and dispersed," "strong and weak," "dry and wet," "fast and slow," "sparse and crowded," "fat and lean," "thick and thin," "connected and disconnected."[1] These may also be interpreted in terms of "balance," "symmetry," "tension," "contrast," "harmony," "proportion," "confrontation," and "yielding."[2] For all the movement and rhythm manifested in the process, there is always a final resolution, the coming to rest at its true center.

Although calligraphy is intimately linked with the content of the language, its beauty is not dependent upon the quality of the composition or the sentiments expressed in it. Similarly, neither the scarring of age on a stone inscription nor the imperfections of an ink rubbing detract from the appreciation by a true connoisseur. As the eminent art historian of the eighth century, Chang Huaikuan, wrote: "He who truly knows calligraphy only looks for its dynamic spirit, and does not notice the shape of the words." Elsewhere Chang also compares the best in calligraphy to "music without sound" and "image without form." As his eyes followed the movement of the brush from character to character and from line to line, observing the details, Wang Hsi-chih's reaction to one work ran thus: "Every horizontal stroke is like a mass of clouds in battle strength, every dot like a falling rock from a high peak, every turning of the stroke like a brass hook, every drawn-out line like a dry vine of great old age, and every swift and free stroke like a runner on his start."[3]

When the total effect of a great piece of calligraphy strikes home, the viewer's response can be likened to a response to music. As the T'ang calligrapher Sun Ch'ien-li described it:

Of the wonders of *shu fa* (art of writing) I have seen many and many a one. Here a drop of crystal dew hangs its ear on the tip of a needle; there, the rumbling of thunder hails down a shower of stones. I have seen flocks of queen-swans floating on their stately wings, or a frantic stampede rushing off at terrific speed. Sometimes in the lines a flaming phoenix dances a lordly dance, or a sinuous serpent wriggles in speckled

1. This list is by the Ch'ing critic Chou Hsing-lien, translated by Ch'en Chih-mai in *Chinese Calligraphers and Their Art* (Melbourne: Melbourne University Press, 1966), p. 202.
2. Ibid.
3. Translation by Lin Yutang, cited by Ch'en, ibid., p. 200.

fright. And I have seen sunken peaks plunging headlong down the precipices, or a person clinging on a dry vine while the whole silent valley yawns below. Some strokes seem as heavy as the falling banks of clouds, others as light as the wings of the cicada. A little conducting and a fountain bubbles forth, a little halting and a mountain settles down in peace. Tenderly a new moon beams on the horison; or, as the style becomes solemn, a river of stars, luminous and large, descends down the solitary expanse of night. All these seem as wonderful as Nature herself and almost beyond the power of man.[4]

In calligraphy, then, as in music, the final test is the evocation of mood through the juxtaposition of movement and repose, harmony and dischord, light and shadow. The famed eighth-century essayist Han Yü once wrote concerning the "delirious cursive" of his contemporary Chang Hsü (see p. 105): "When his heart is moved by joy or anger, privation or sorrow, resentment or yearning, intoxication, listlessness or indignation, his cursive calligraphy will reveal it."

As one Western student of Chinese art says of Chinese painting, it is "like a piece of music brought to life again by a brilliant pianist or violinist, coaxed out of an orchestra by the conductor's baton,"[5] so the same may be said of calligraphy. Each specimen is like a performance in a time-honored style, and a collection of specimens is like an album of records made up of memorable performances from the past. It is in this spirit that this book is offered, in the hope that greater visual familiarity will stimulate greater interest and appreciation of this uniquely Chinese art.

JIU-FONG L. CHANG

November 1974
Seattle

4. Translation by Sun Ta-yü, cited by Ch'en, ibid., p. 198.
5. Fritz Van Briessen, *The Way of the Brush: Painting Techniques of China and Japan* (7th ed.; Rutland, Vt.: Charles E. Tuttle Co., 1974), p. 35.

SUGGESTIONS FOR FURTHER READING

Ch'en Chi-mai. *Chinese Calligraphers and Their Art*. Melbourne: Melbourne University Press, 1966.

Chiang Yee. *Chinese Calligraphy: An Introduction to Its Aesthetics and Technique*. 3rd ed. Cambridge, Mass.: Harvard University Press, 1973. Available in paperback.

Chinese Art. Vol. 3. New York: Universe Books, 1960.

Driscoll, Lucy, and Toda, Kenji. *Chinese Calligraphy*. 2nd ed. New York, 1964.

Eche Tseng Yu-ho. *Chinese Calligraphy*. Philadelphia: Philadelphia Museum of Art, 1971.

Karlgren, Bernhard. *Sound and Symbol in Chinese*. Rev. ed. Hong Kong: University Press, 1962.

Lin Yutang. "Calligraphy as an Abstract Art." In *Pleasures of a Nonconformist*, Chap. 33. Cleveland and New York: World Publishing Co., 1962.

Sullivan, Michael. *The Arts of China*. Berkeley and Los Angeles: University of California Press, 1973. Available in paperback.

Tsien Tsuen-hsiun. *Written on Bamboo and Silk: The Beginnings of Chinese Books and Inscriptions*. Chicago: University of Chicago Press, 1962.

Yang Lien-sheng. "Chinese Calligraphy." In *Chinese Calligraphy and Painting in the Collection of John M. Crawford, Jr*. New York: Pierpont Morgan Library, 1962.

CHINESE CALLIGRAPHY

An Introduction

THE BEGINNING OF CALLIGRAPHY

Recent excavations in Pan-p'o, Sian, have unearthed a number of clues to the beginnings of Chinese written characters dating back to 4,000 B.C. However, much research has yet to be done before we can establish what connection these clues have with later linguistic symbols. (see p. 244)

Ts'ang Chieh was an historian in the days of the Yellow Emperor. According to legend, he had four eyes on his forehead and was able to communicate with the supernatural. He closely observed the movements of the heavenly bodies and the patterns on the shells of tortoises and marks made by birds. He recorded what he observed and derived words from the patterns which he recorded. ▶

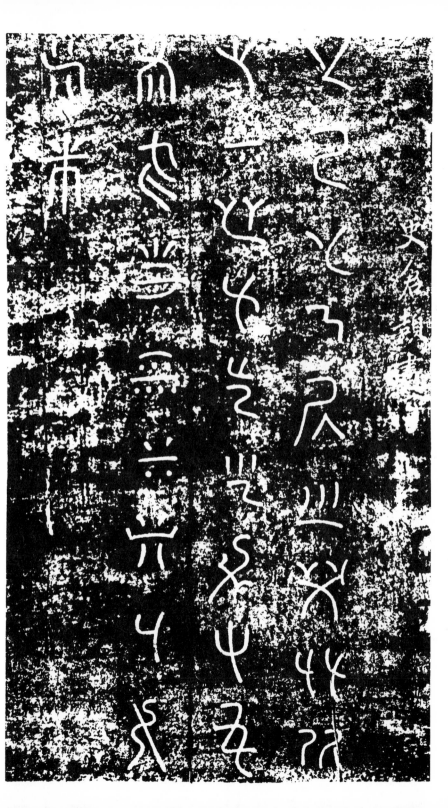

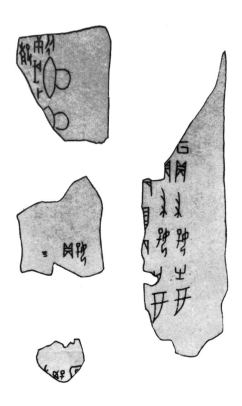

Oracle Bone Inscriptions
Bronze age Cir. 1339 – Cir. 1281 B. C.
Engravings on tortoise shells and animal bones used for
divination, first discovered at Anyang towards the end of
the 19th century. A source of inspiration to some calli-
graphers since the Ch'ing Dynasty when they were adopted
as a script and used as models.

4

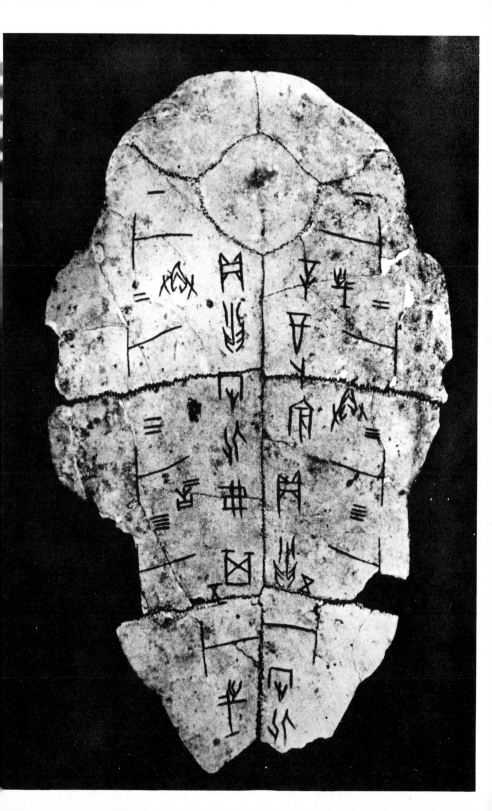

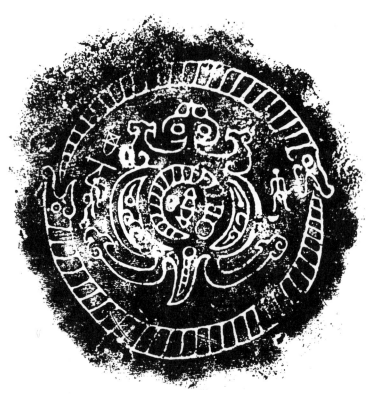

Bronze Script with animal motifs, 1766–1122 B.C.

Hieroglyphic writing on bronze, Cir. 1300 B. C.
Probably first used to record official title of tribal digni-
taries and names of totem animals. ▶

6

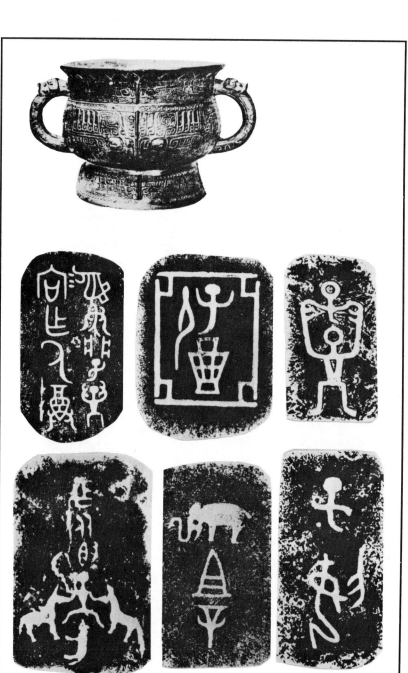

7

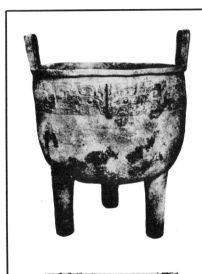

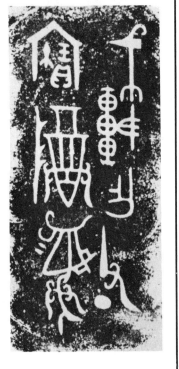

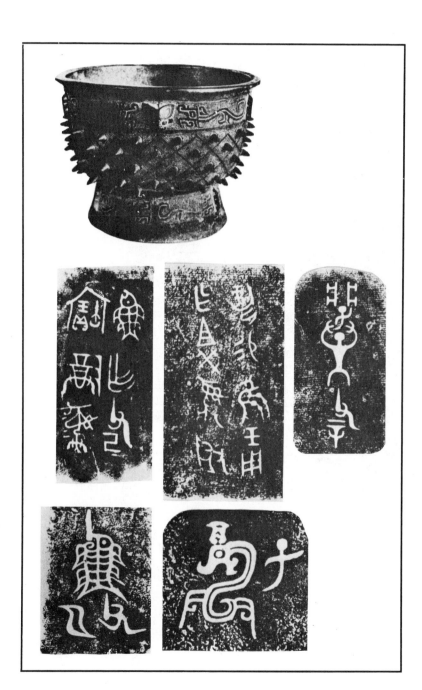

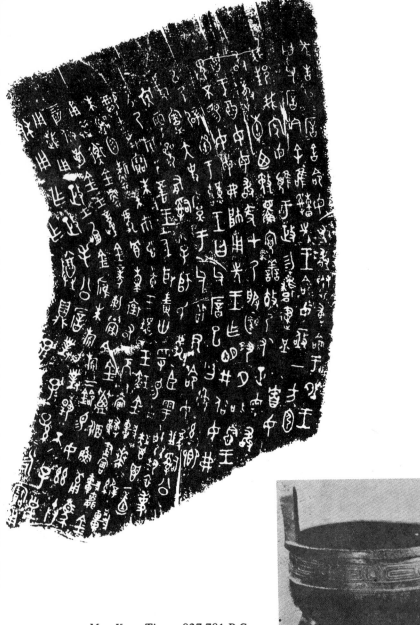

Mao Kung Ting, c 827-781 B.C.
unearthed in mid-19th century
ta chuan script

10

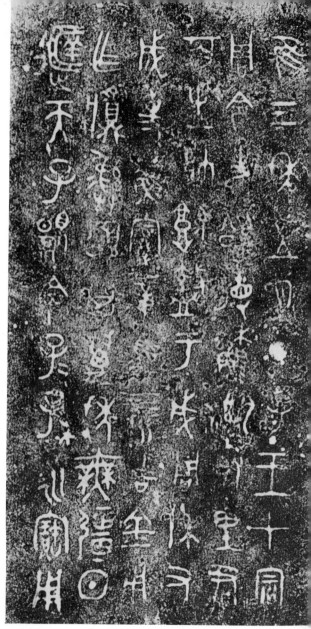

Shih Sung Kuei 827-781 B.C.
ta chuan script

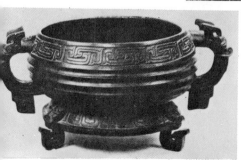

11

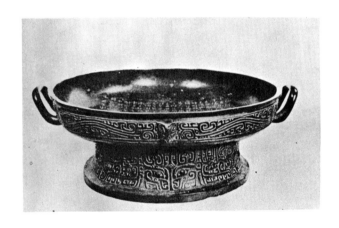

San Shih P'an, 861-827 B.C.
A ceremonial basin
ta chuan script

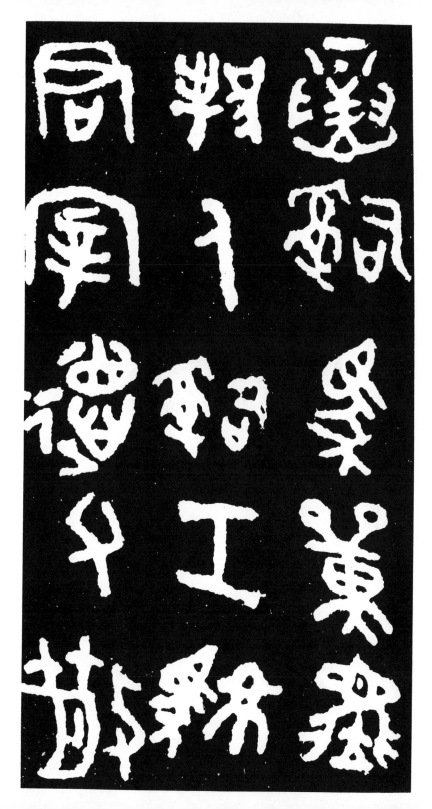

Shih Ku Wên (Stone Drum Script)
So called because it was carved on stone in the shape of a drum; a form of *ta chuan,* but bearing some resemblance to the *hsiao chuan* devised by Li Ssu, a transitory step from the former to the latter.

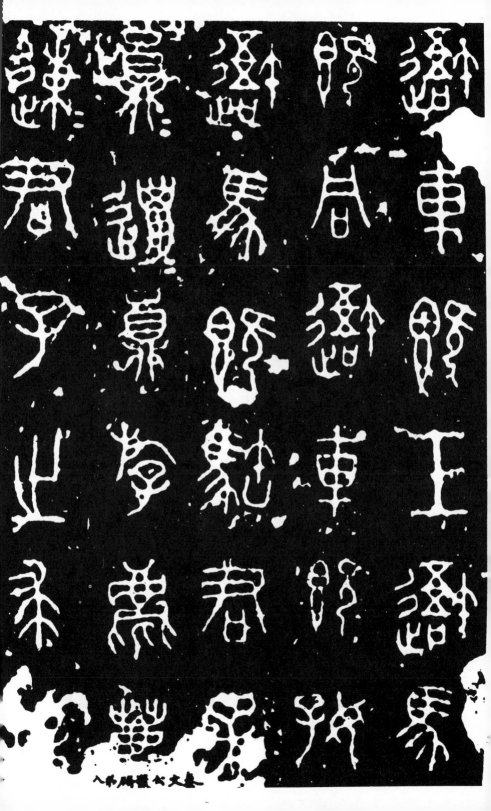

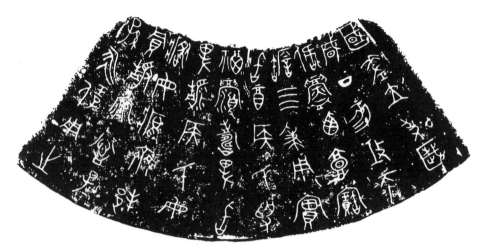

Kuo Ch'ai Tan, Cir. 589 B.C.

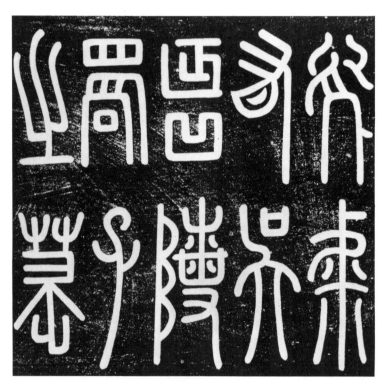

Attributed to Confucius, 551-479 B.C.

16

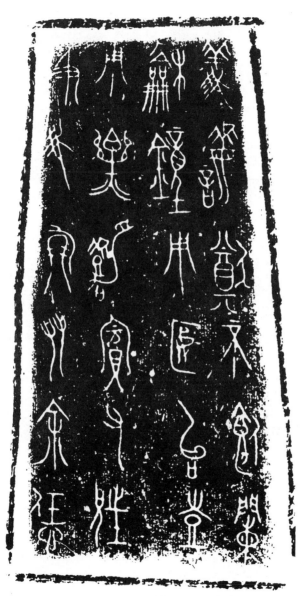

Wang Sun I Che Chung, Cir. 6th century B.C.

17

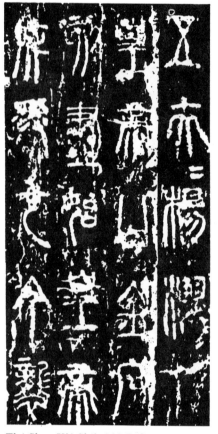

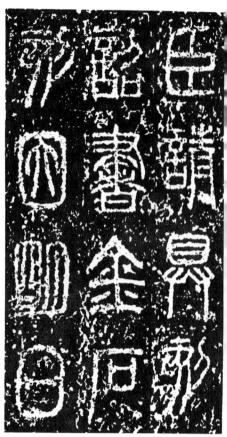

T'ai Shan K'ê Shih 219 B.C.
— using the script designed by Ch'in Dynasty calligraphers.

Lang Yeh T'ai K'e Shih 219 B.C. ▲
Engraved on a cliff called Lang Yeh; only ten lines of
characters have survived; calligraphy possibly by Li Ssu.

18

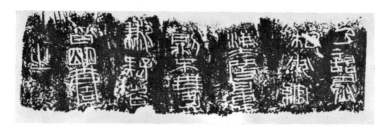

Inscription on bronze weight, 209 B.C.
(Described as *ancient li shu*)

Pottery tomb figure of this period.

19

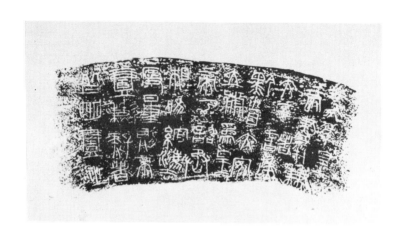

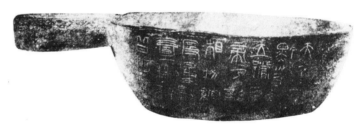

Inscription on bronze measure, 209 B.C.

I Shan Pei
An example of *hsiao chuan*　▶
Attributed to Li Ssu, Prime Minister to the First Emperor
of Ch'in (b. 219 B.C.). The calligraphy: balanced, dignified
and austere; however, the original stone perished in a fire
and the present specimen is a rubbing from a date-wood
engraving. The poet Tu Fu wrote these lines: "The I Shan
tablet was lost in a wild fire; the date-wood copy suffers
from being too bold."

皇帝立國　維

初在士　　世

嗣王討伐　

維歲動四極

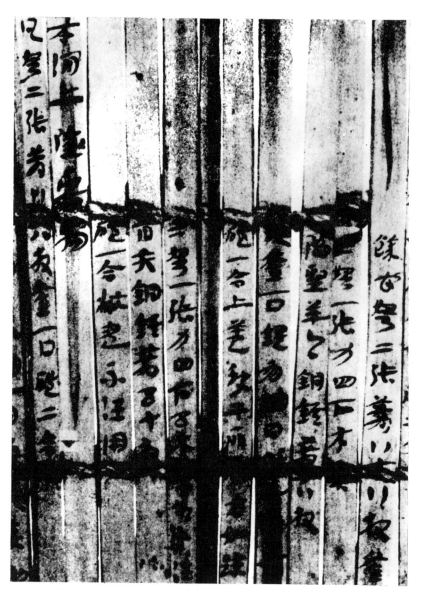

Han Bamboo Script (Chu Yen) 58 B.C.

Han Wooden Script (Tun-huang) 94 B.C. − 25 A.D. ▶
Normally used for recording years of a reign, on wood or
on bamboo slips. Probably the earliest specimens of *li shu*,
a script developed by Ch'êng Miao in the time of Shih
Huang Ti. A major break-through in writing, for the first
time it brought out the full capabilities of the brush. It
enabled faster writing and opened a new era in calligraphy.

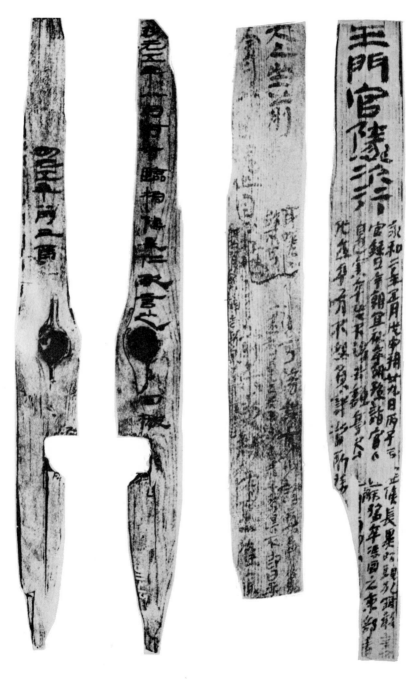

23

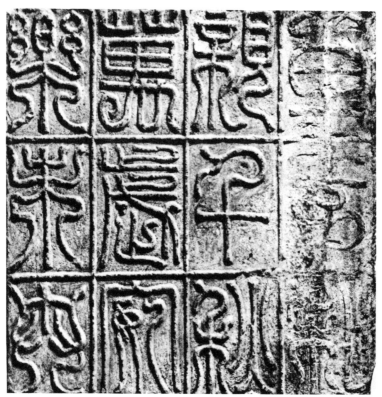

Square Brick commemorating a marriage alliance with the
Huns; about 1st century B.C.

Gilded bronze figure of a leopard of this period.

Bronze inscription, c. 1st century B.C.

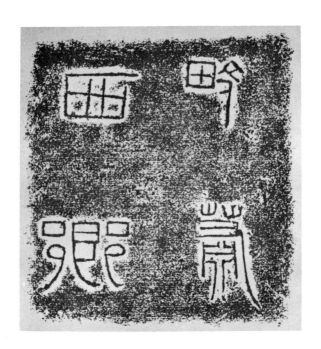

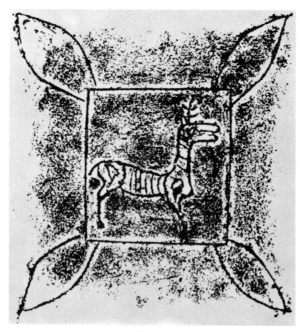

Bronze inscription 1-5 A.D.

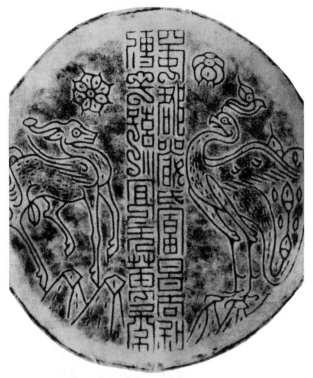

Yen Shih Bronze Basin, 2nd century

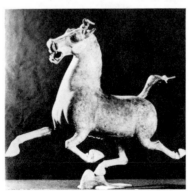

Bronze figure of a galloping horse of this period.

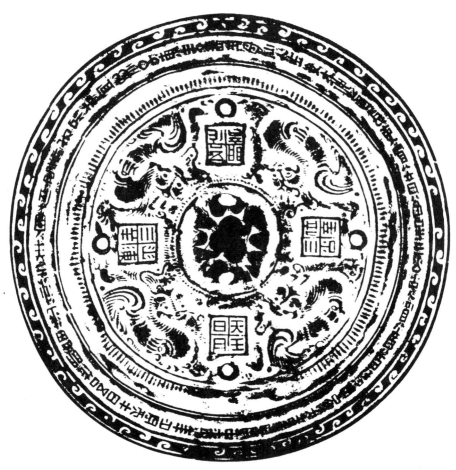

Four-Creature Mirror, 190

Chia Liang Ming, 9 A.D.

Lai Tzu Hau Kê Shih, 16 A.D.

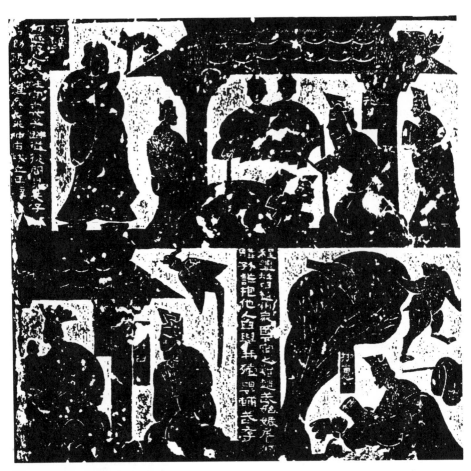

Wu Liang Ancestral Hall Stele, 147

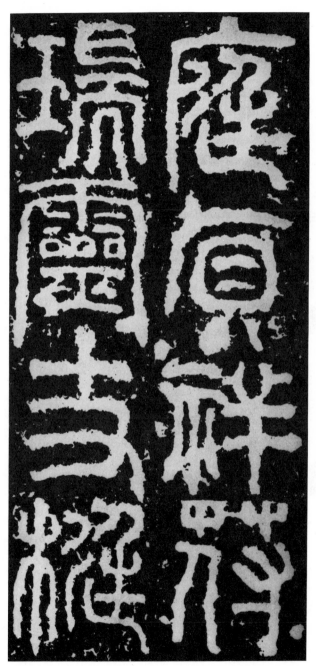

Sung Shan K'ai Mu Miao Shih Chueh Ming, 123

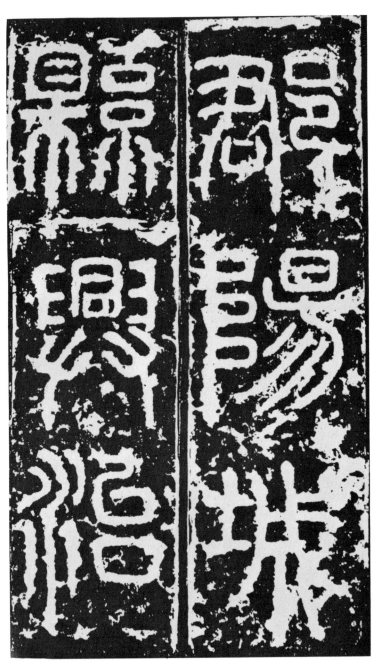

Sung Shan Shao Hsi Shih Chueh Ming, 123

32

Kuang Ho Seventh Year Basin, c. 185

Bronze model of a chariot of this period.

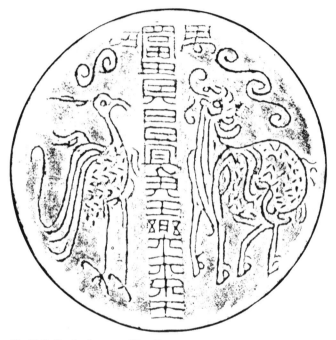

Yu Shih Basin, bronze, Han Dynasty

Tile Script, Han/Six Dynasties.

35

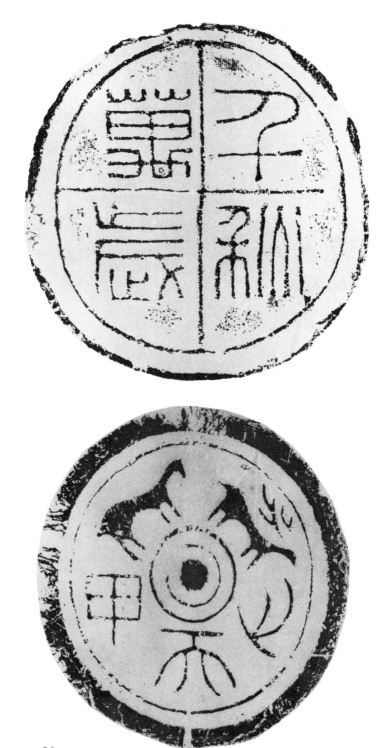

36 Tile Script, Han Dynasty

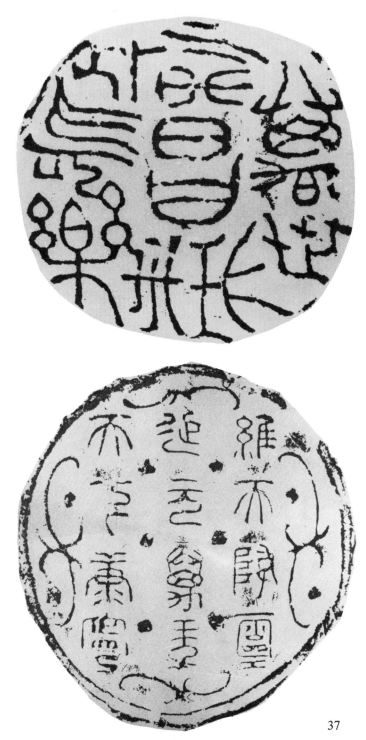

37

Tile Script, Han Dynasty

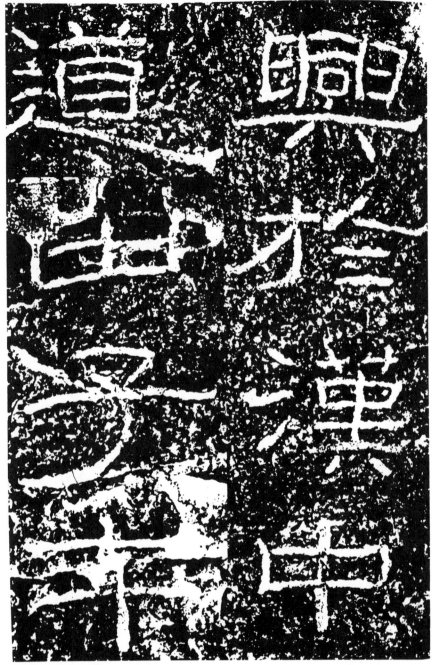

Shih Men Sung, 148, attr. Yang Meng Wen
li shu

I Ying Pei, 153 ▶
li shu

司空言
徒更魯
更叅前
彊稽相
司首瑛

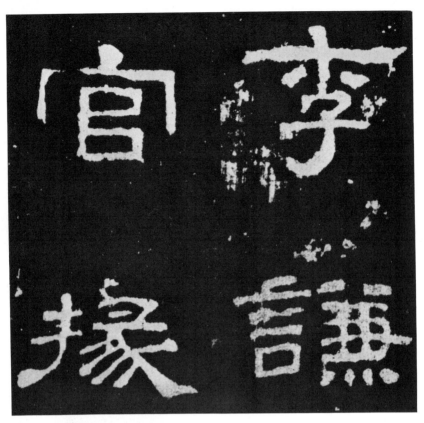

Bronze elk of this period.

Shih Ch'en Pei, 169 ▲
li shu ▶

上 謙 臣

尚 頓 晨

書 首 長

臣 死 史

晨 罪 𠬝

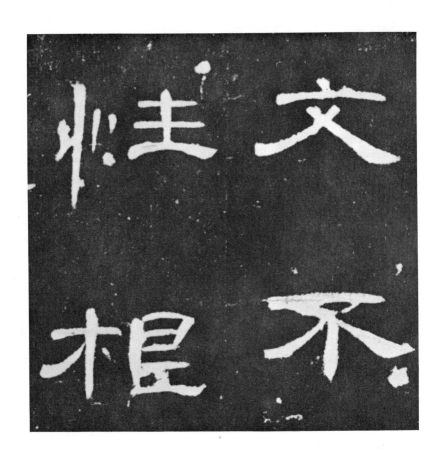

Ts'ao Chüan Pei, 185
han li shu

緯無文不綵賢

孝之性根生於

心牧養李祖母

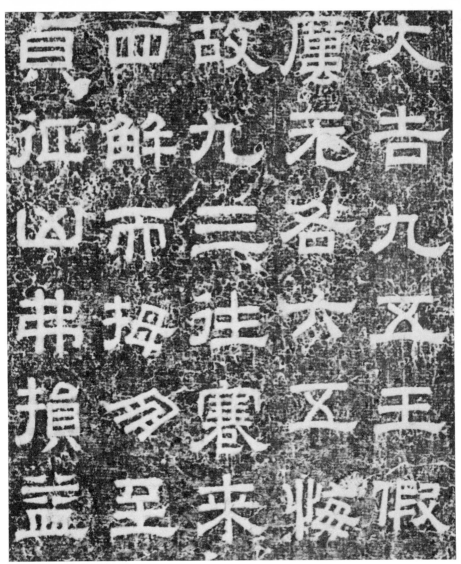

Hsi Ping Shih Ching
Inscription of classics on stone 183 A.D. (Earliest specimen)
Possibly by Ts'ai Yung
The style may be described as Pa Fen, or 80%
chuan shu and 20% *li shu* (in structural appearance)

P'ing Fu T'ieh, attributed to Lu Chi 201-203 A. D.,
probably the earliest calligraphic manuscript extant, it can
be described as *ts'ao shu*, using *chuan shu* as a base. ▶

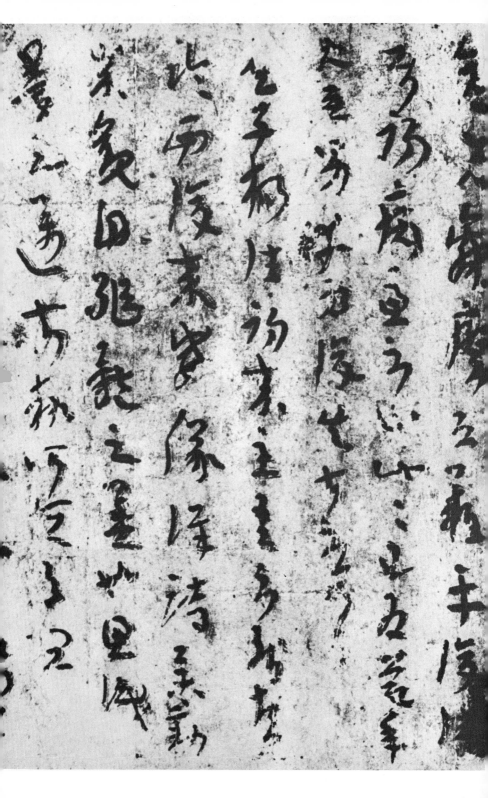

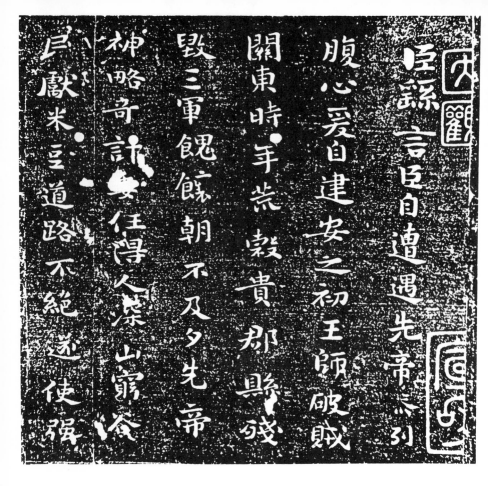

臣繇言臣自遭遇先帝二列
腹心爱自建安之初王師破賊
關東時年荒穀貴郡縣殘
毀三軍餽餉朝不及夕先帝
神略奇計安任得人深山窮谷
民獻米豆道路不絕遂使强

Chung Yu (Chung Yao) 151-230
A high official in the Court of Wei; considered to be the
father of *K'ai-shuu or chen-shu* (regular or formal script).
When he failed to obtain information from Wei Tan about
T'sai Yung's way of executing a certain stroke, he was so
disappointed he wanted to kill himself. However he
succeeded in getting a specimen of the calligrapher's
handwriting and he modelled his own calligraphy on it
and evolved the personal style that we know today. "A
subtle balance of strength and pliability, the dots and
strokes manifesting a peculiar appeal, limitless in its
depth, archaically elegant beyond words." (ch'en)

臣縠言戎路無行履險冒寒徙

以無任不獲扈從企佇懸情

有寧舍即日長史逯充宣示令

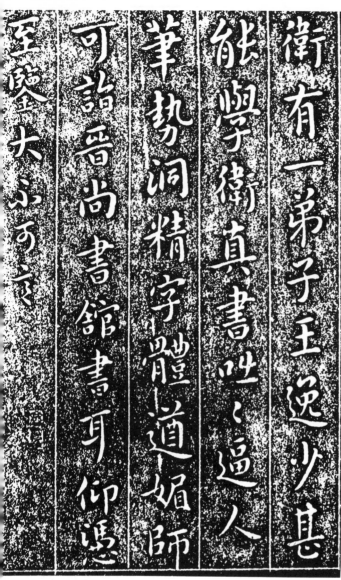

衛有一弟子王逸少甚
能學子衛真書咄咄逼人
筆勢洞精字體遒媚師
可謂晉尚書館書耳仰憑
至陛至大不可云

Madam Wei 3rd — 4th century
Specimen's authenticity doubtful. A T'ang Dynasty calligrapher describes her calligraphic style thus: "Like a fairy playing with her shadows, a red lotus flower reflected on the pond." (Ch'en) A well known couplet reads "I first studied the calligraphy of Madam Wei, but alas I never succeeded in surpassing Wang Hsi Chih!"

Pottery model of this period.

48

Specimen : page 49

衛稽首和南近奉勑寫急就章遂不得
與師書耳但衛隨世所學規摹鍾繇遂
廢多載年廿者詩論草隸通解不敢上
呈衛有一弟子王逸少甚能學衛真書咄
逼人筆勢洞精字體遒媚師可語令尚書
館書耳仰憑至鑒夫……芟芝弟子衛

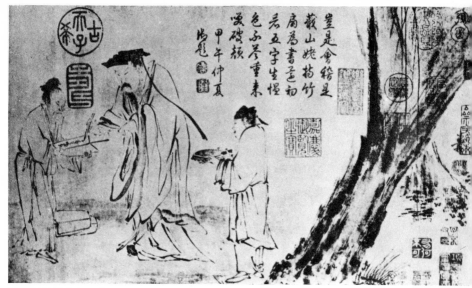

Wang Hsi Chih inscribing a fan for an old woman. Liang K'ai, Cir. 1140-1210

Wang Hsi Chih, 307-365 (303-379?)
A general in the Court of Tsin Dynasty generally
considered the greatest calligrapher of all time.
He was particularly remembered for the *Lan T'ing Hsü*
(Orchid Pavilion Preface), the authenticity of which is
currently the subject of heated dispute.
His calligraphy was described as being "like a dragon
scaling Heaven's gate and a tiger lying at rest in a
phoenix's chamber."
He was extremely fond of swans and was often persuaded
to write in return for gift of a swan. In fact, some say that
his calligraphic style was inspired by the graceful move-
ments of that bird.
Lan T'ing Hsü (Orchid Pavilion Preface): see P.56-7
Huang T'ing Ching: its style has been described as "fairy
flying among the clouds and dancing on the waves."
Emperor T'ai-tsung of T'ang was inordinately fond of
Wang's calligraphy and was instrumental in the preserva-
tion of many of Wang's works. He engaged master artists
to make delicately executed copies of them.
Except for the one on p. 55, all the specimens by Wang
Hsi Chih here are in *hsing shu* or running script, a
variation of *chen shu.*

50

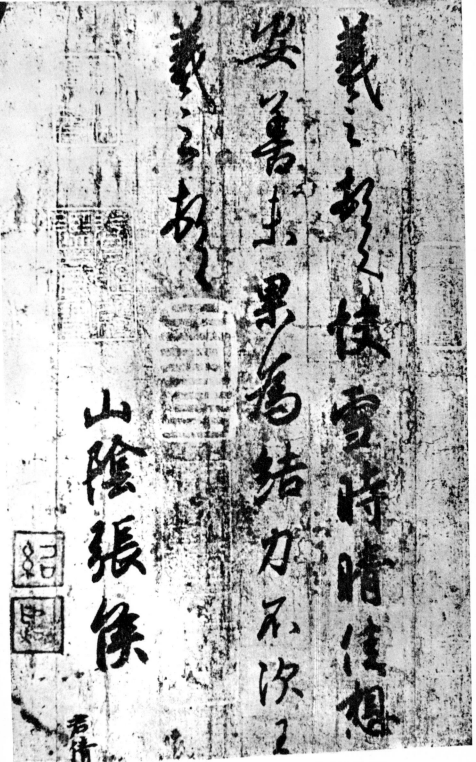

義之頓首快雪時晴佳想
安善未果為結力不次王
義之頓首
山陰張侯

Kuai Hsueh Tieh

大唐三藏聖教序
太宗文皇帝製
弘福寺沙門懷仁集
將軍王羲之書
蓋聞二儀有像顯覆載

Sheng Chiao Hsü

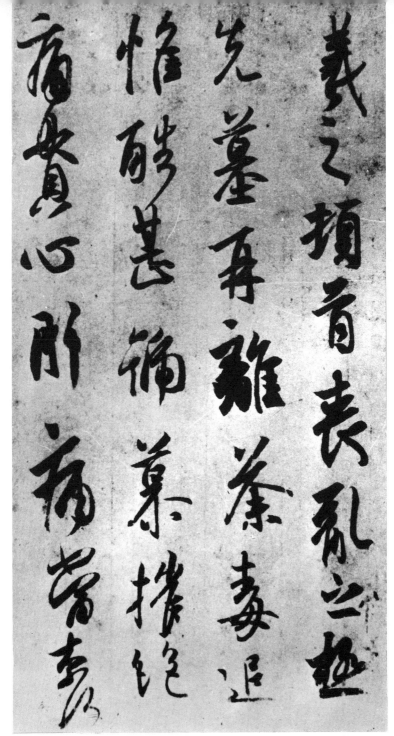

義之頓首喪亂之極
先墓再離荼毒追
惟酷甚號慕
摧絶痛貫
心肝痛當奈何奈何
雖即脩復

Sang Luan Tieh

◀ Composed from collections of Wang Hsi-chih's calligraphy
by Friar Huai Jen, T'ang Dynasty.

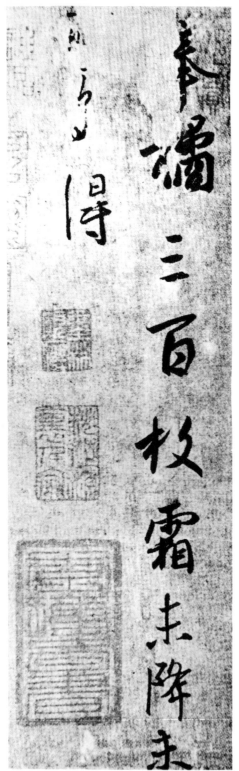

Feng Chü Tieh

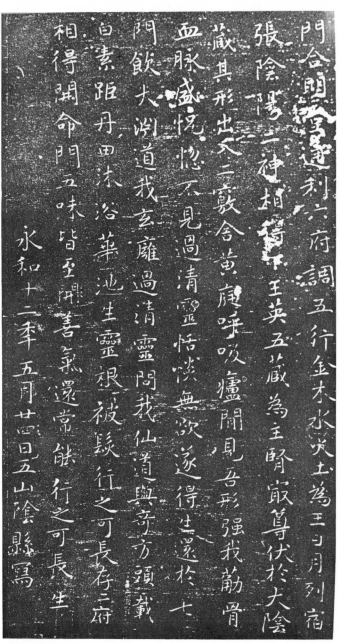

Huang Ting Ching

是日也天朗氣清惠風和暢仰
觀宇宙之大俯察品類之盛
所以遊目騁懷足以極視聽之
娛信可樂也夫人之相與俯仰
一世或取諸懷抱悟言一室之內

56

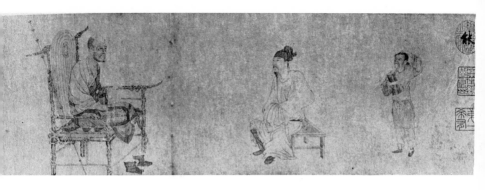

THE THEFT OF THE ORCHID PAVILION PREFACE

Lan T'ing Shü, the Orchid Pavilion Preface by Wang Hsi-chih, a sublimely beautiful specimen of the *running script* was allegedly written in a state of insobriety. It was highly treasured by the calligrapher himself, for although he tried many times to re-write that piece, he never succeeded in improving on it.

During the reign of the first Emperor of T'ang, this manuscript was reportedly in the possession of Pien Ts'ai a monk who inherited it from Friar Ch'i Yung, a seventh generation grandson of Wang Hsi-chih. Pien Ts'ai was himself a great calligrapher and he valued the Preface so much that he risked losing his scalp by vigorously resisting repeated pressure to relinquish it in favour of Emperor T'ai-tsung, an ardent admirer of Wang Hsi-chih's calligraphy.

The Emperor desired to possess the Preface so much that he would not rest without gaining his objective. Hsiao I, a senior court official, was entrusted with the task of getting the Preface by any means. Hsiao disguised himself as a retired scholar and soon succeeded in insinuating himself into the confidence of Pien Ts'ai, first by playing chess and then by composing peoms with him. It was weeks before he had a chance to broach the subject of calligraphy when Pien Ts'ai, in a buoyant mood after some cups of wine, started to demonstrate his dexterity with brush. Hsiao was quick to praise his skill and commented that it reminded him of Wang Hsi-chih, the supreme master, many of whose works he used to know when he was a court official. He further boasted that he had seen the best of Wang, upon which the monk in a moment of indiscretion, said: "You haven't seen the best until you have seen the Orchid Pavilion Preface." Pien Ts'ai then showed him the Preface which he kept in a secret niche under the roof.

That was enough. Hsiao waited till the monk went away on a religious mission to a neighbouring city, and by stratagem gained access to the monk's sanctuary and spirited away the object of his quest.

The Emperor was overjoyed, generously rewarded Hsiao for the exploits and forgave the monk.

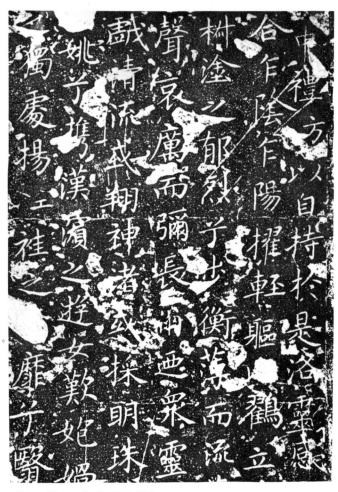

Wang Hsien Chih, 344-386

A son of Wang Hsi Chih.

When he was a young boy, his father once tried to test his potentiality by finding out how firmly he held his brush. The theory was that the more firmly the brush was held the more likely it was that the calligraphy would be good. He was writing one day when his father got behind him and suddenly pulled his brush. It did not leave the boy's hand. The happy father said afterwards, "This son of mine will be a great calligrapher."

58

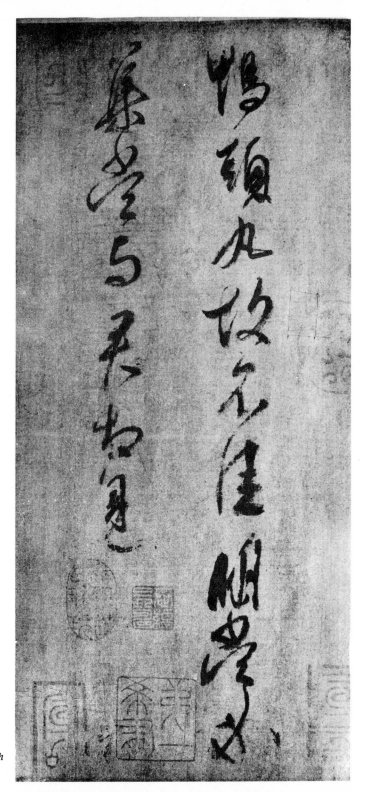

Ya T'au Wan Tieh

綴蘭靜道弊行軍
凄搽之德戎晉歸
仁九尊唱於名郷
柬帛隽光聞庭獨

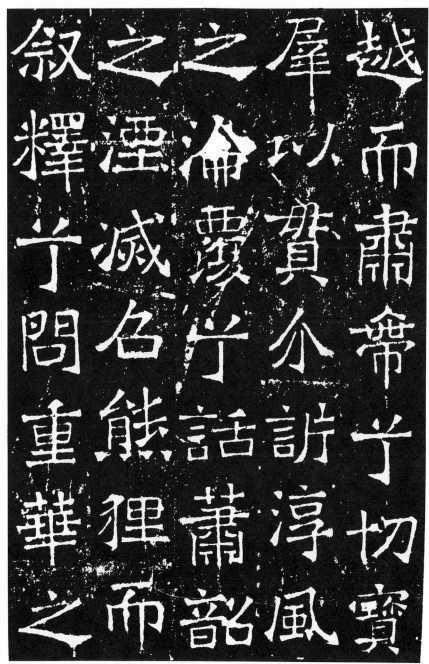

Tiou Pi Kang Wen, Cir. 440, attributed to Chu Hao.

◀ *Chuan Pao Tzu Pei*, 405
Full of masterly strength. Infinitely variable in its brush-
work. Wonderfully reserved. 61

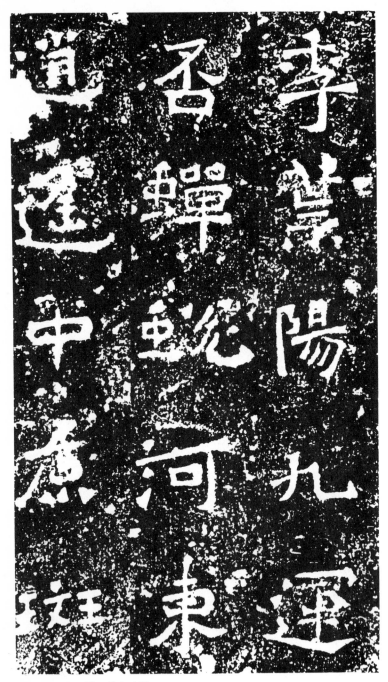

Ch'uan Lung Yen Pei, 458
62

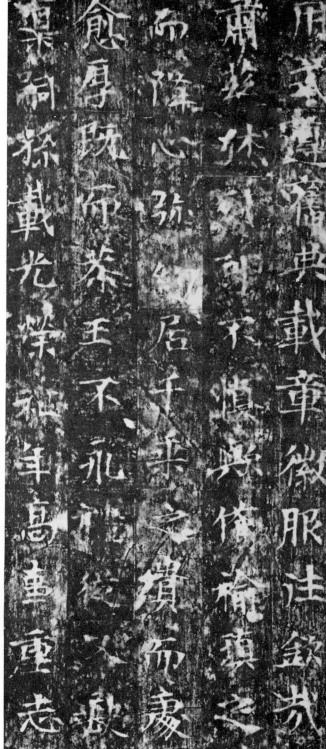

Marble sculpture of this period.

Wang Shih Mu Chih, 520

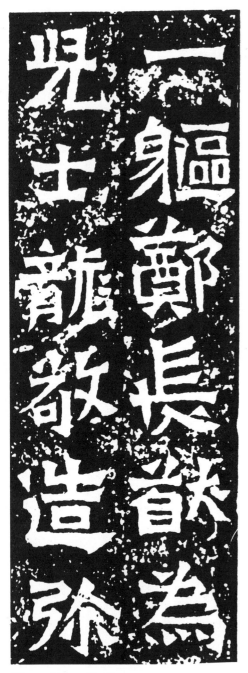

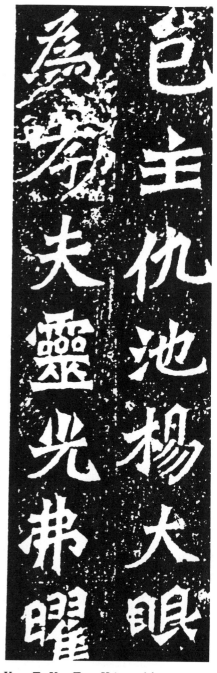

Cheng Ch'ang Yu Tsao Hsiang, 501

Yang Ta Yen Tsao Hsiang, 6th century

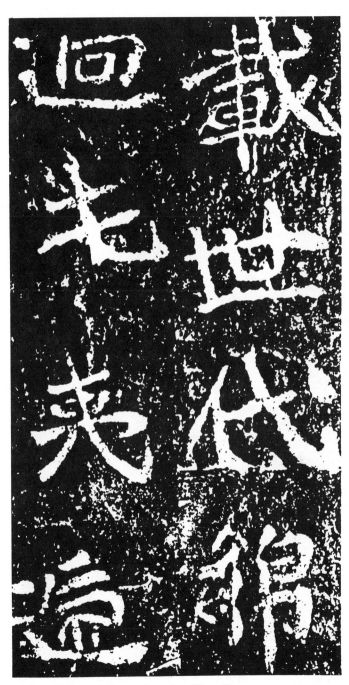

Shih Men Ming, 509, attributed to Wang Yüan

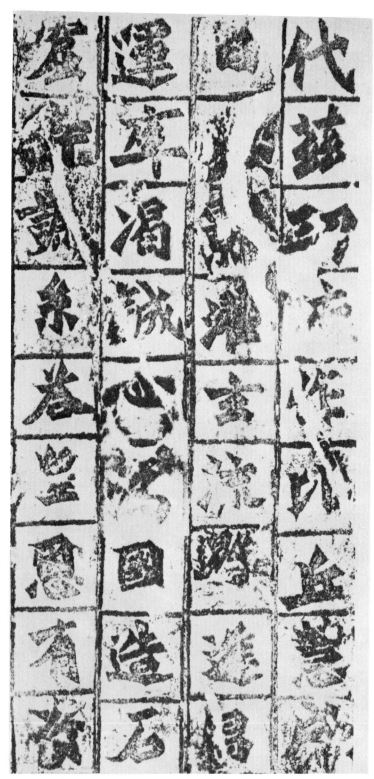

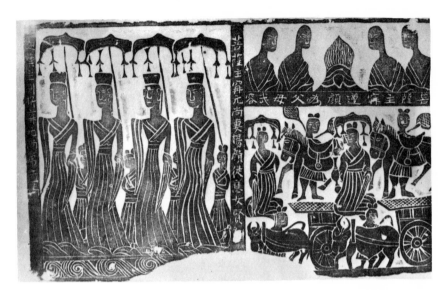

Anon. 4th — 5th century

Shih Ping Tai Pei, 498

◀ Specially noted because the characters are "embossed".

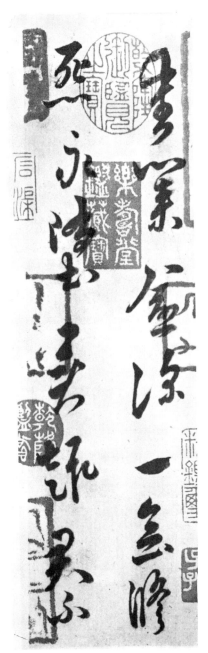

Hsiao Yen, King of Liang, 502-557

Pottery figure of this period.

Cheng Tao Chao, fl. 511

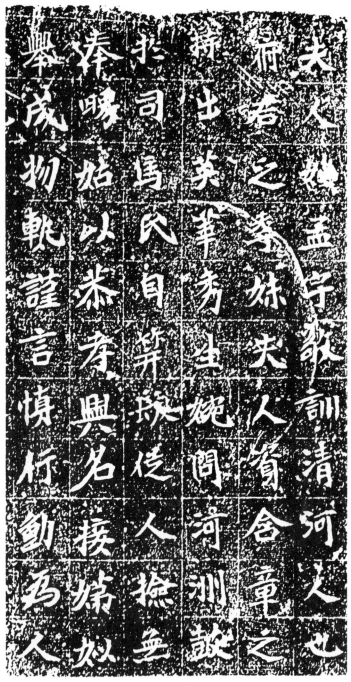

Meng Hsi Pei

I Ho ming 514
Written in memory of a beloved crane.
Large characters; possibly by Tao Hung Ch'ing ▶
"Light as angel's wings."

祖此胎入禽得

出三下仙亭

Ch'ang Mêng Lung Pei, 523
chên shu with some reminiscence of *li shu.*

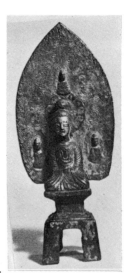

Bronze Buddha of this period.

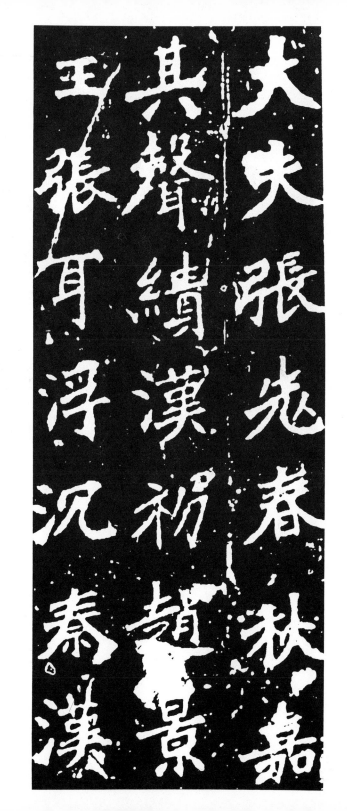

大夫張先春秋嘉

其聲續漢初趙景

王張耳浮沉秦漢

The Thousand-Character Essay, 6th century
Chih Yung, monk, a seventh generation descendant of
Wang Hsi-chih. He spent years transcribing the
"Thousand-Character Essay" and distributed copies
amongst Buddhist monasteries and temples.

74

下睦夫唱婦隨外受傅訓

八睦青呢姻隨外更偕訓

入奉母儀諸姑伯姊猶子

入牽母儀诸姑伯方群子

T'ai Shan Chin Kang Ching, 550-577
Engraved on granite in a valley in T'ai Shan; in
large characters measuring 40-45 c.m.
The custom of writing Buddhist texts on cliff faces in the
mountainous Northern provinces was widespread during
the 6th century.

如是我聞一時佛在舍衛國祇

77

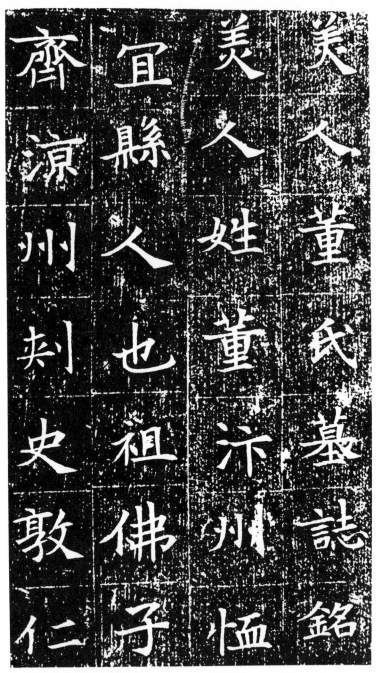

美人董氏墓誌銘

美人姓董汴州恤

美人董氏墓誌銘

齊涼州刺史敦仁

宜縣人也祖佛子

Mei Jen Tung Shih Tomb Inscription, 597 A.D.

漢　河　跡
而　而　螫
孫　峻　元
秀　跱　高
屬　巨　掌
江　靈　岭

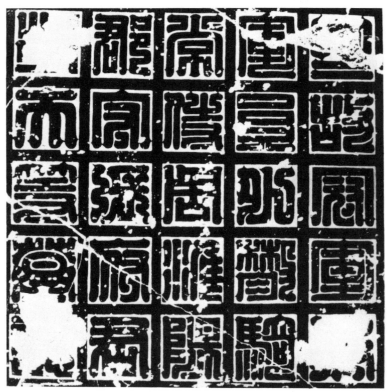

Chang Ch'ien Mu Chih C. 560

Glazed pottery figure of this period.

Ch'ang Hei Nü Mu Chih, 593
Chen shu with some touches of *li shu.* ▶

80

魏故南陽張府君墓

誌君諱玄宇黑女南

陽白水人也出自皇

帝之苗裔昔在中葉

彤闈闡化年化月有詔封泄南郡

公宣錫重珪瑞祀崇禴沐車服

章事優前典與屬九地縋維西

醫曜毁瘠載形袞觶遵祀闡

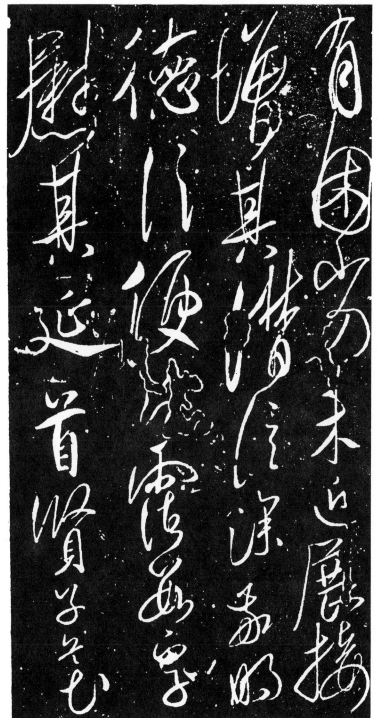

有固必有末追屡撼

潜其滋滋注之涤高弱

德以便龟霍画皇

屡其远首贤子之也

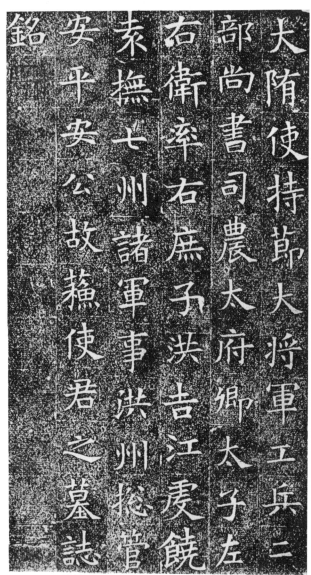

大隋使持節大將軍工兵二部尚書司農太府卿太子左右衛率右庶子洪吉江憂饒袁撫七州諸軍事洪州總管安平安公故藕使君之墓誌銘

Anon., Shu Dynasty

Wen Chuan Ming
Emperor T'ai-tsung of T'ang, 597-649
Took after the style of Wang Hsi-chih, his idol. ▶

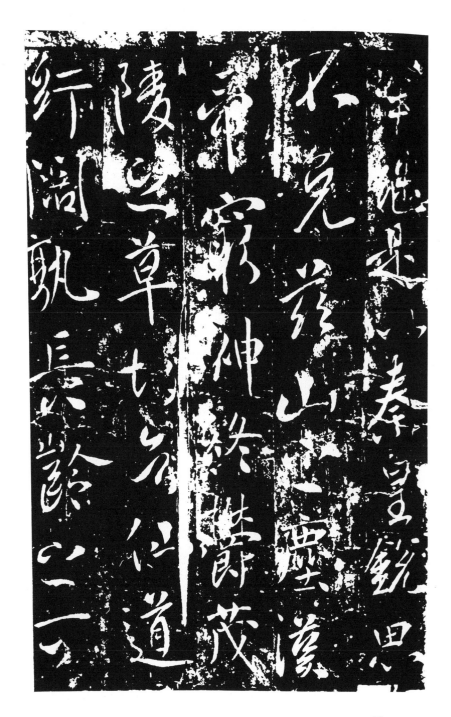

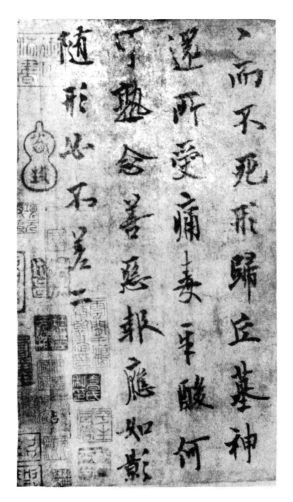

Ou Yang Hsun, 557-645

Liked to use brushes with fox-hair as the core and rabbit hair outside. "Extreme decorum" is the impression given by his calligraphy which is characterised by straight, angular, rigid strokes. It is praised for "combining the grace of the serpent and the vigour of the warrior".

Its extreme elegance and refinement accounts for its being often adopted as model by examination candidates.

The specimen on page 89 was written at the age of eighty-five.

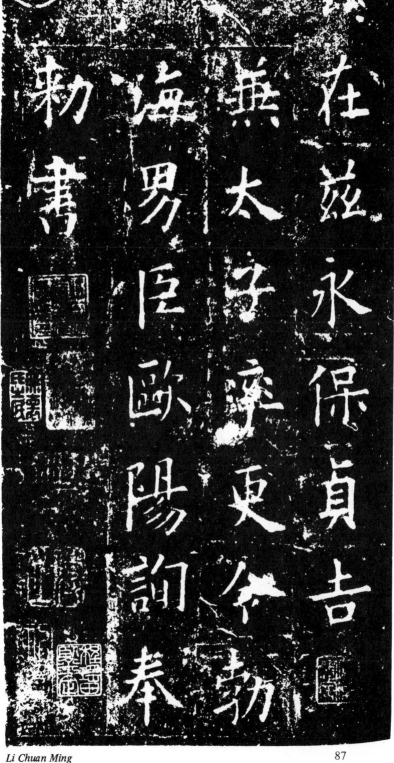

絲在茲永保貞吉　無太子率更令勅　海男巨歐陽詢奉　勅書

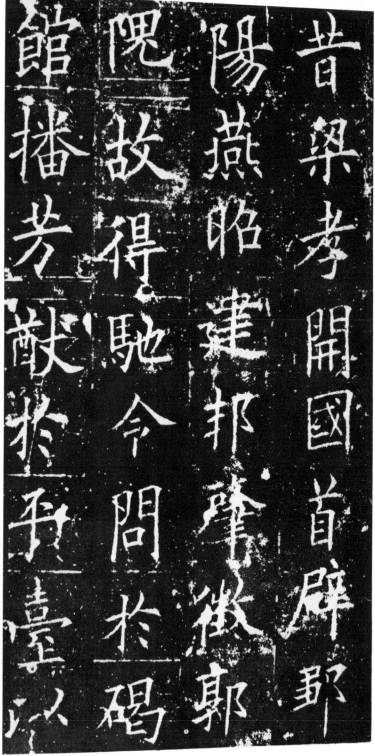

昔梁孝開國首辟鄒
陽燕昭建邦肇徵郭
隗故得馳令問於碣
館播芳猷於臺以

Huang Fu Tan Pei

交友投分　切磨箴規　仁慈
隱惻造次　弗離節義　廉退
顛沛匪虧　性靜情逸　心動
神疲守真　志滿逐物　意移
堅持雅操　好爵自縻　都邑

Thousand Character Essay

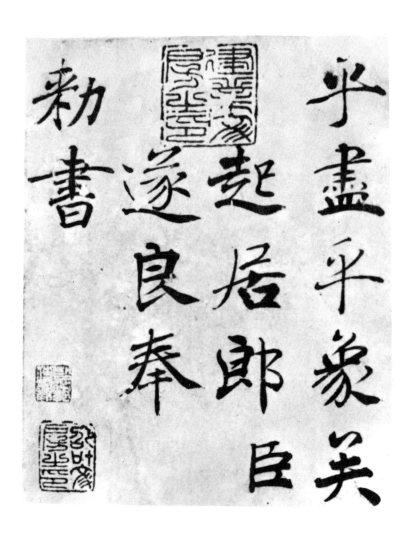

.Ch'u Sui Liang 596-658
Court Recorder to T'ai-Tsung of T'ang Dynasty and rose
to be Duke of Honan.
Calligraphy characterised by a certain feminine grace.

90

斗極咸羆狼山之圍渚歸池東
旋若木西旆絛支龍鄉委青鳥
耶來儀大矢乘時悠哉利見文龜
浮沼應龍在淀漓露飛甘卿雲呈
絢松萬望韋瑤華方薦仙丹餤

Tai Chung Ai T'sè

華之文澤及昆蟲

金匱流梵說之偈

遂使阿耨達水通

神甸之八川者

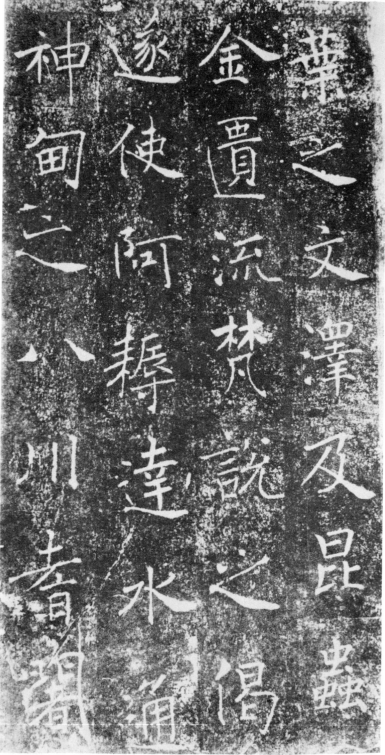

Sheng Chiao Hsü

亦既來儀居于至德之
觀公卿虛己士女翹心
於是高視神州廣開眾
妙懸明鏡於講肆陳鴻

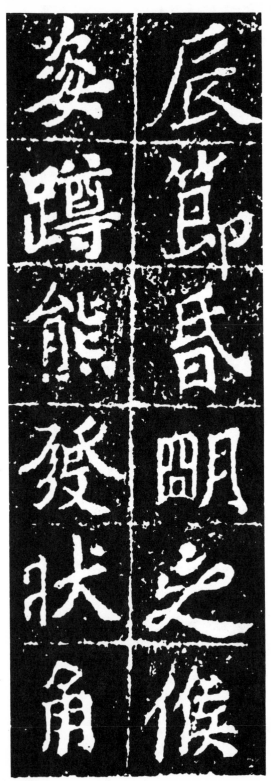

Ch'ing Lung Kuan Sung Ming
Emperor Jui Tsung 662-716

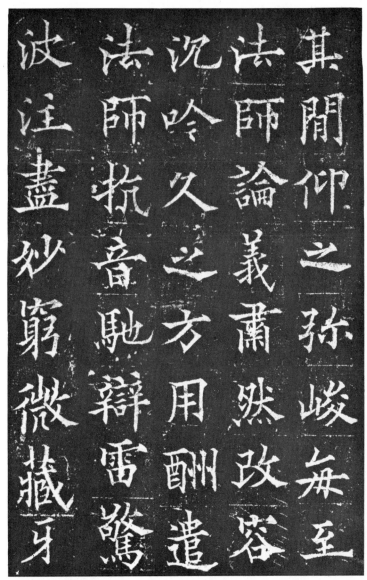

Tao Yin Fa Shih Pei
Ou Yang T'ung, d. 691, son of Ou Yang Hsun
"Precarious, as if poised over a precipice."
He was said to have used brushes of fox and rabbit hair.

95

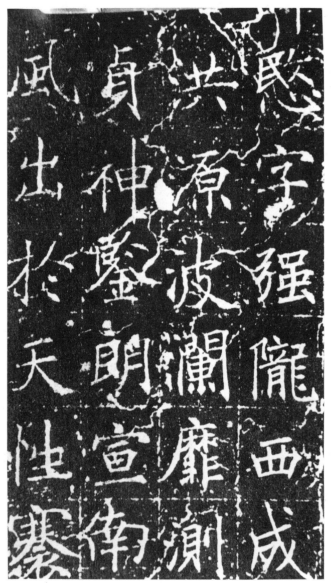

Li Min Pei, Fei Shao Chen d. 705

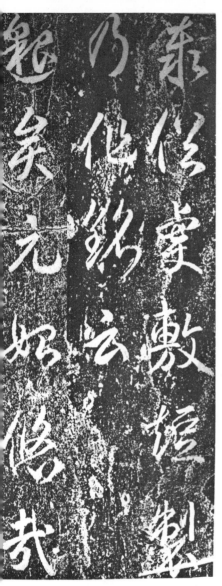

Shêng Hsien T'ai Tzu Pei
Empress Wu Tŝe Tien, Cir. 700

The top part of the stele above.
Notice the bird-strokes; a specimen of
the decorative *fei-pai* style.

▶

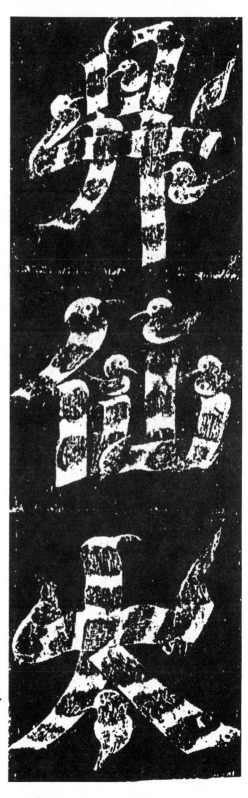

勅國儲為天下之本師
導乃元良之教將以
本固必由教先非求中
賢何以審諭光祿大
夫行吏部尚書充禮

Yen Chen Ch'ing, 709-785
His Chên-shu or K'ai-shu is characterised by ponderous
rounded strokes, often regarded as being highly en-
gineered. Described as "dignified, solemn, exuberant,
powerful."

不及详阅姑

随罗馄饨绝

入战更定

书

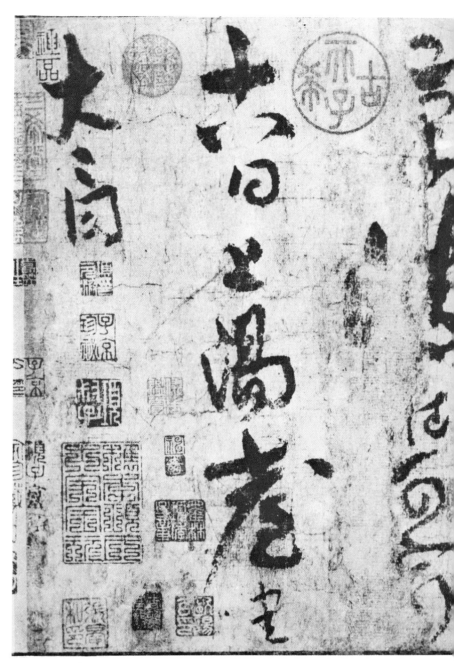

Li Po, 701-762, poet.

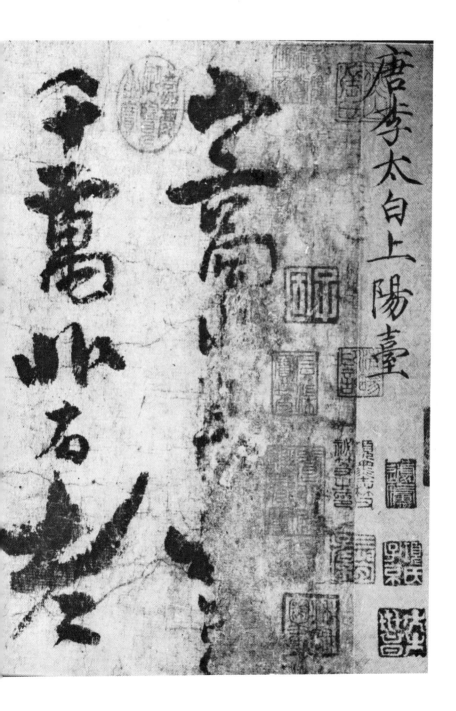

唐李太白上陽臺

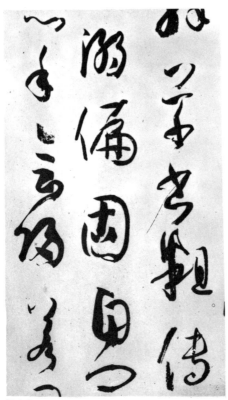

Detail

From *Shu Pu*
Sun Ch'ien Li, fl. 687
Reputedly surpassing Chang Hsü and Huai Su in skill.

Pottery figure of a Central Asian horseman of this period.

與妍因俗勿聽言辨之化

高以訊言而浮辭一要矣又三

言輒弊從菜將但勞張芳弦

古不兼時人乢同異而後文黃

棚遲遲買子月以勿曉言於

窈窕文又玉韜於楹於古乢

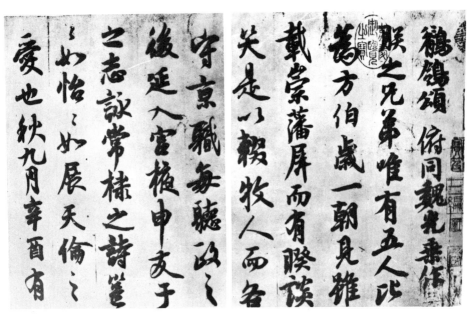

Chi-ling Sung
Emperor Hsuan-tsung, 685-762
"Once when Emperor Hsuan-tsung was celebrating a reunion with his five brothers, a flock of wagtails settled in the trees before the palace. The Emperor was so delighted that he commanded a poem to be written, to which he wrote the preface with his own hand."

Attributed to Chang Hsü, active 713-740 ▶
"delirious cursive script."
"Dancer holding a sword which glitters and whirls in the air in musical rhythm."
Nicknamed "the Mad Chang", he often wrote after a great deal of wine.

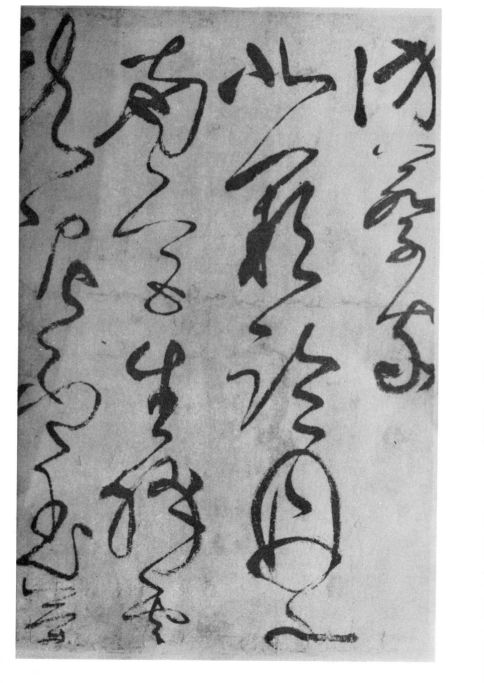

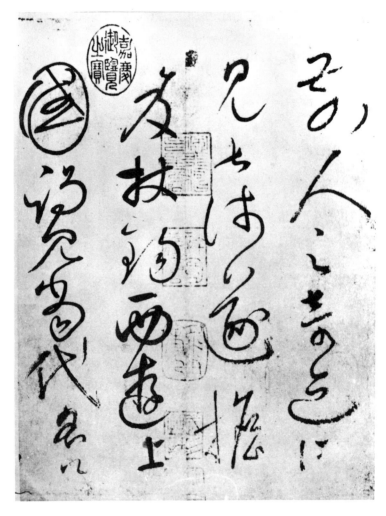

Huai-su, 736 — after 798
Entered a Buddhist monastery in youth owing to poverty
— had to use banana leaves to practice calligraphy as he
could not afford paper.
Learned calligraphy from Chang Hsu.

Specimens : pages 107-109

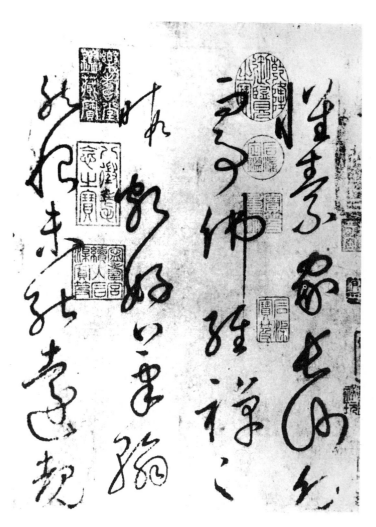

Nicknamed the drunken monk. Calligraphy shows extreme
nervous energy, resourcefulness, vivacity. In mad ecstasy,
he wrote on walls and clothes.
Used to bury used brushes in a solemn ceremony.
Liked to write after heavy drinking. *Ts'ao Shü*

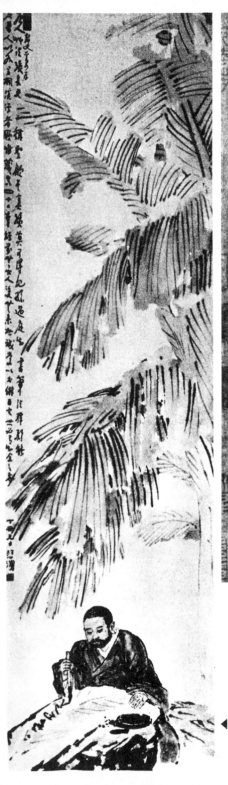

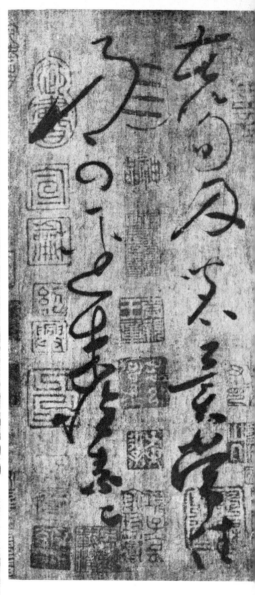

Huai Su practising calligraphy on banana leaf
Hsu Pei-hung, 1895-1953

止蒙箴威不可為

先无王樣情手以

放形說言以台優

句而事为自不古

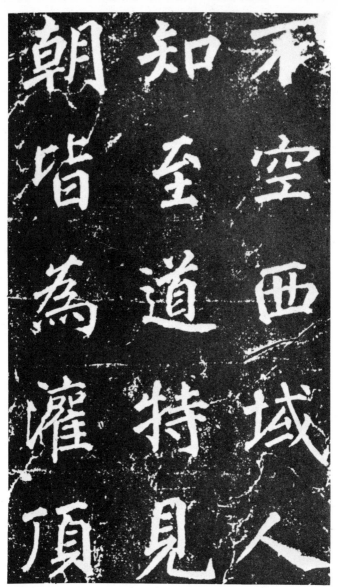

Pu Kung Ho Hsiang Pei, Hsu Hao, 703-782

Ling Fei Ching
Chung Shao-ching, fl. 738, a tenth generation descendant
of Chung Yu.
Effeminate beauty; often used as model for exercises in
chên shu or *kai shu*. ▶

110

七月八月庚辛之日平旦入室西向叩齒九

通平坐思西方西極玉真白帝君諱浩庭字

素羅衣服如法乘素雲飛輿從太素玉女十

二人下降齋室之內手執通靈白精玉符授

與地身地便服符一枚微祝曰

白帝玉真号曰浩庭素羅飛幕羽盖鬱青晏

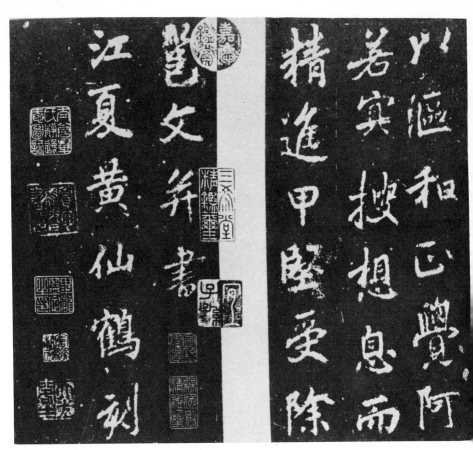

Lu Shan Chih Pei

Carved onyx of this period.

Li Yung (Li Pei-hai), 678-747
Took after Wang Hsi-chih; his calligraphy was used as
model by Chao Meng-fu. "Those who take my calligraphy
as a model can only succeed in producing dead stuff; the
calligraphy that looks like mine must be full of faults." (Li)

112

原州長史華陽縣開
國以贈寧州刺史諱
孝斌或集事雲雷擁
花為將或淡然窒
欲超然遠尋好山海
畨墓祠仙事且求人

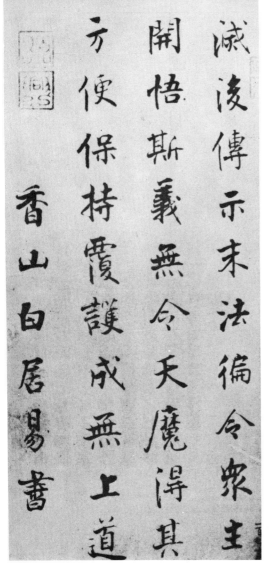

滅後傳示末法徧令衆生
開悟斯義無令天魔得其
方便保持覆護戒無上道

香山白居易書

Po Chü-i, 772-846, poet.

White glazed spittoon of this period.

Liu Kung Chüan 776-865;
modelled after Yen Chên Ch'ing;
strokes like gnarled branches of an aged tree, bony but
sinewy. ▶

集賢殿學士兼判院事上柱

國賜紫金魚袋柳公權書并

篆額

玄祕塔者大法師端甫靈骨之

所歸也於戲為丈夫者在家則

張仁義禮樂輔天子以扶世

導俗出家則運慈悲定慧佐

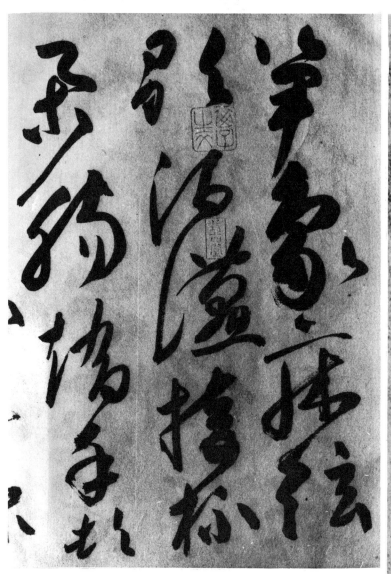

Monk Kao-Hsien, fl. 800

Yang Ning-shih, 873-954
Chiu Hua T'ieh
A return to the grace and elegance of the Ts'in period.
A departure from the solemn dignity of the T'ang artists
and a return to the grace & elegance of the Ts'in epoch.

116

謝犬信

董蓑謹犬

畫寢乍興朝飢正甚忽

簡翰猥賜盤飱當一葉報

秋之初乃並花遣味之始助

甚肥荐實謂珎羞充腹

之餘銘肌載切謹修狀陳

空階重疊上垣衣白畫初

長社鷺歸蒼畫海棠人

Lin Pu, 967-1028

襄啓自離都至南京長子

旬潟傷寒七日遂不起某

南歸殊為榮華不意災禍

此恸動悲懇念衰痼日

念也承不及書弁永平信蓋

用慟惻且又度江不及相見

Ts'ai Hsiang, 1012-1067
High official of Sung Court
His style shows us that we are entering the territory of
Sung art.

119

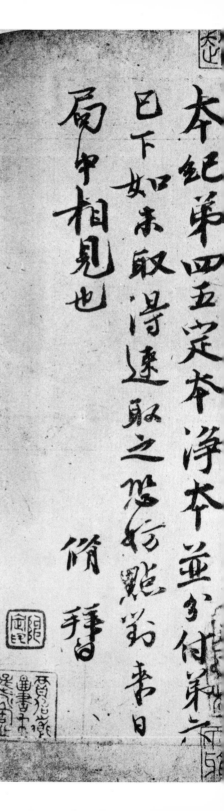

本紀第四五定本淨本並已付第二
已下如未取得遠取之恐妨點對書日
局中相見也

脩再拜

佩啟佩以衰病餘生蒙
上恩寬假取具懇至仰遂
歸老自杜門里巷與世日疎
惟竊自念幸得早從
當世賢者之遊其於歡懷
德義未始以忘於心耳近聞
寺丞自洛來出
所惠書甚為感慰何可勝言

因得御詞
起居喜承
宴豫優閑
顧況清福春候暄和更異
為時愛重以副搢紳所以有
望者非獨田畝私書之久區
也不宣佩再拜
端明侍讀留臺
執事
三月初二日

Ou Yang Hsiu, 1007-1072

White porcelain ewer of this period.

先太尉與
故相國龐公同為群牧判官
故省副陳公與
龐公善先以孫子得拜
陳公於攝下元豐二年八月乙丑晦
陳公之孫洙法曹過洛以
公手書詩藁相示追計五十年矣為呼人生
如寄苟無才志之美所以能不朽於後者頼選
文耳苟無賢子孫其湮沒不顯於世可勝道
哉先竊自悲侍
公之久今日乃得睹
公之文又喜
法曹君之賢能顯歙其
先烈是敢嗣書於
群賢之末

涑水司馬光

Szu Ma Kuang, 1019-1080

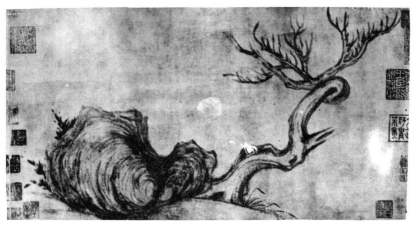

Tree & Stone, Su Shih (see p. 122)

何以賴晚年更似杜陵翁右臂雖存

耳先聵人将蟻動作牛鬭我覺風

雷真一嘻閒塵掃盡根性空不須更枕

清流派大朴初散失混沌六鑿相攘更

朦壞眼花亂墜酒生風口業不傳詩亦

債君知我蘊此是賊人生一病今先差

但恐此心終去了不見不聞還是礙今君

疑我情僻新婚作噉詩窮險怵須防

額庳上三丁美放筆端風雨快

次韻秦太虛見戲耳詩

Su Shih, 1036-1101
Better known as Su Tung Po, "the Gay Genius".
Alternately in high office and in exile.
Sources of inspiration: Wang Hsi Chih, Yang Ning-shih,
Yen Chên-ch'ing.
His calligraphy is characterised by a certain "obesity" but
nevertheless is full of strength which according to some
"permeates through the paper."
He was said to have liked using brushes made with a few
mouse whiskers in the centre covered by sheep's hair.

122 Specimen : page 123

盡也而又何羨乎且夫天地
之間物各有主苟非吾之

自我来黄州已過三寒
食年
欲惜春去不

123

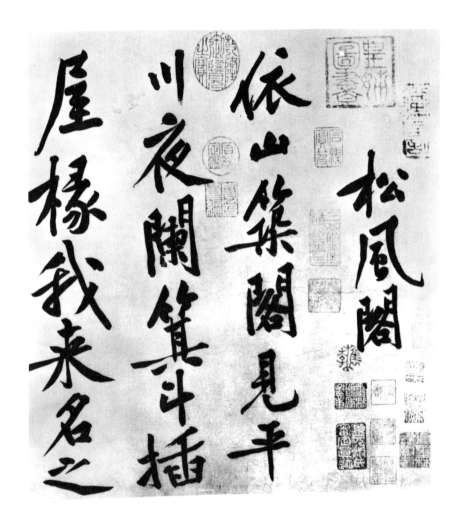

屋椽我来名之　依山築閣見平　川夜闌箕斗插　松風閣

Huang T'ing Chien 1050-1110 A.D.
Best known as one ∞of the twenty-four paragons of
filial piety. He devoted himself for a year to caring for
his ailing mother without leaving her bed-side.
Intimate student and friend of Su Shih.
Extraordinary originality in brushmanship which he
does not try to conceal.
"Swift, pugilistic movement."

124

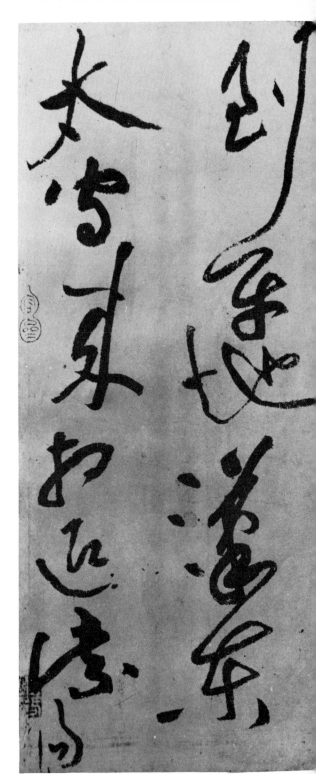

Celadon wine jug of this period.

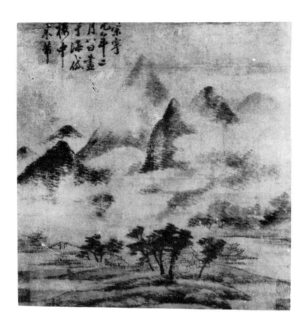

Mi Fu, (Mi Fei), 1051-1107
Noted also for his painting.
Style: unrestrained exuberance; unconventional.
Known as 'Mi the Eccentric,' he often wore robes in the fashion of the T'ang Dynasty. He had a passion for grotesquely-shaped rocks and was known to have prostrated himself before them, addressing them as his brothers.
Was Adviser in Calligraphy and Poetry to the Court.
He wandered up and down the rivers of East China, collecting and exhibiting art objects and he called his watercraft "Boat of Calligraphy and Painting"(Shu Hua Chuan). His calligraphy is modelled mainly after that of Ch'u Sui-liang and the Tsin masters.
"restless, dynamic, mysterious, playful"
"Like sailing in the wind and riding a horse into battle, his writing is exhilarating"
Of his own approach to calligraphy Mi says that other people write with one side of the brush while he writes with four sides, utilising dry and wet ink tonalities. It was recorded that he tried to paint with sticks of sugar cane, the ends of which had been sucked and squeezed dry.

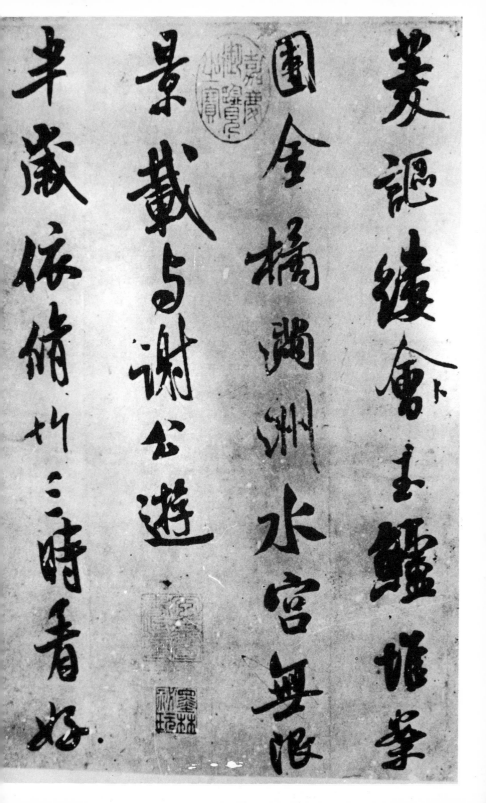

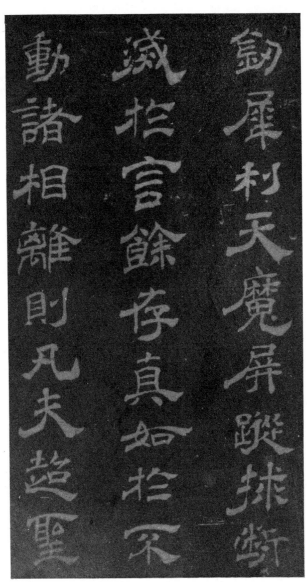

Mi Fei

Mi Yu-jen 1086-1165
Son of Mi Fei
Modelled after his father. ▶

128

褚遂良書立唐賢諸名世士
書中為秀穎然得羲獻之法最
多者真字有練法自一成字非
諸人可以此肩此書蓋其晚筆
紹興丙辰十二月丙五日友仁審定

Emperor Hui-tsung of Sung, 1082-1135
Avid patron of art.
Painter of birds and flowers.
His calligraphy is a completely personal one, with a special appellation: "slender gold script."
A gifted artist but a disastrous ruler. He neglected affairs of state to devote himself to aesthetic pleasures. The country was overrun by Jurchen forces and Hui Tsung and his family were taken prisoners, thus ending the Northern Sung Dynasty.

130

欲借嵯峨萬仞崇故將工

巧狀層峯數尋蒼色如煙

合一并盤根似蘚封院宇

接連常藉竹池亭權映

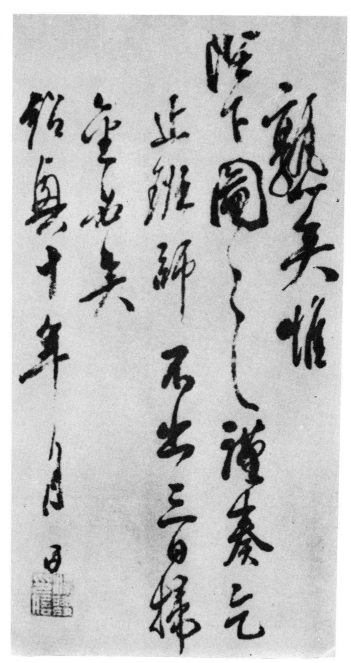

Yüeh Fei, 1103-1141 famous general. Letter written to
Emperor Kao-tsung.

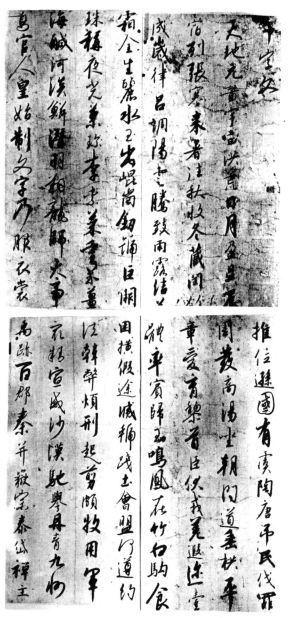

Emperor Kao-tsung, 1107-1187
Note extreme resemblance to Wang Hsi-chih whose calligraphy he assiduously imitated.

133

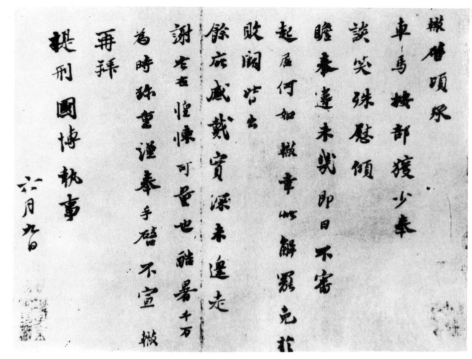

擬啓頃承
車馬捧部獲少奉
談笑殊慰傾
瞻奉違未幾即日不審
起居何如擬章此解寂冗於
賤閑皆出
餘底感戴實深未遑走
謝者悚惶慄可量也酷暑千万
為時弥重謹奉手啓不宣擬
再拜
提刑國博執事
六月九日

Su Ch´e, 1039-1112, brother of Su Shih

Celadon tripod vessel of this period.

Lu Yu, 1125-1210 ▶

空遠眼好
雲閑去樹
芭蕉風振枯

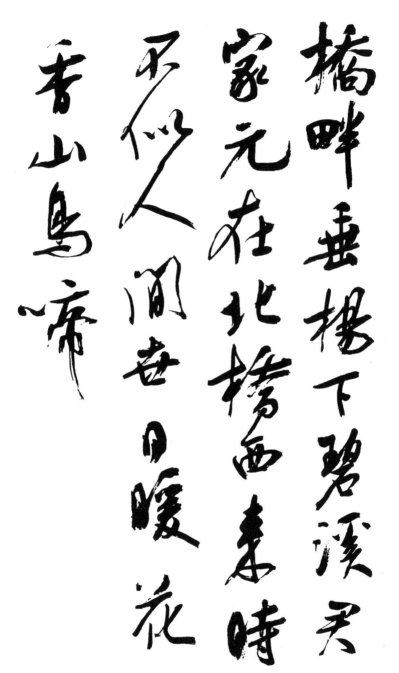

橋畔垂楊下碧溪頭
家元在北橋西來時
不似人間也日暖花
香山鳥啼

Wu Chü, fl. 1140.

Specimen : page 137

忘歸不覺鬢毛斑

好事鄉人尚相遙斷

嶺不連西望眼送君歸

遊楚王山

137

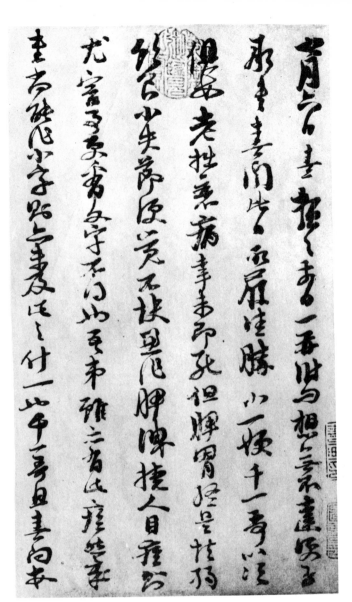

Chu Hsi, 1130-1200
Greatest confucian scholar of Sung Dynasty who started a
school of his own based on the sage's teachings.

Wu Yüeh, fl. 1145
"flowing-silkstrand script"
The illustration shows a detail of a scroll containing a poem
by Wang An-shih and Su Shih. ▶

Porcelain ewer and bowl 12th/13th century

139

說 衰晚驟常冗劇

髇冒暑毒魚內血

淋之疾楚苦良甚

不逮觀涤為愧

Wu Yüeh (see p. 138)

Wu Yüeh (see p. 138)

Chang Chi Chih, 1186-1263 ▶

佛遺教經

釋迦牟尼佛初轉法輪度
阿若憍陳如最後說法度
須跋陀羅所應度者皆巳
度訖於娑羅雙樹間將入

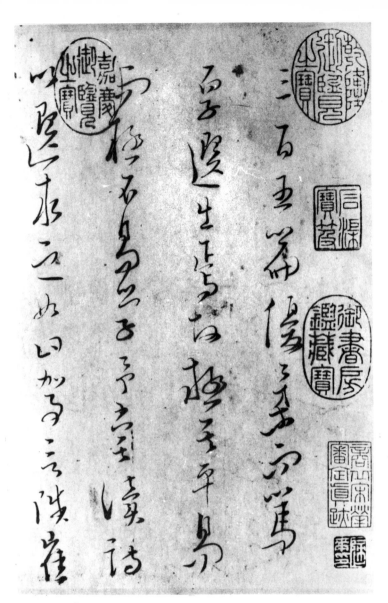

Wen Ti'en Hsiang, 1236-1282
Loyal Sung official, noted for his *Chêng Ch'i Ko*

Chang Yü, 1277-1348
Took after the calligraphy of Li Yung. ▶

142

緣雲覓絲作清裘身以飢鷹曉脫韝
一上孤峰盤礴時巨鰲
神木披風飄處月邊下方鐘隱樓
藏者陸沈誰在瀼社州
登南筆色頁

人風裁賴此以存具眼者當以予為知言
姆事之家不見唐摹不足以言知書者
方外張而謹題

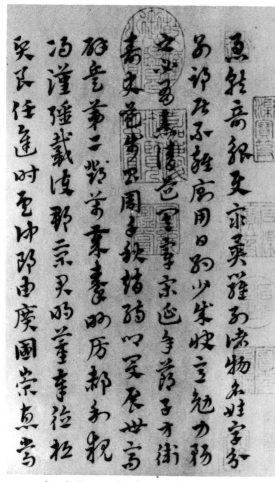

An example of *Chang ts'ao* (copy of Chi Chiu Chang)

Blue and white porcelain vase of this period.

Chao Meng-fu, 1254-1322
Became Kublai Khan's court calligrapher in 1286.
While imbibing the influence of the Ts'in masters, he was
especially adept in copying the style of Wang Hsi Chih
"Sweet, pretty" – Ch'en
"Soft, undulating" – Chiang

Specimens : pages 145-146

余叢屢遊姑蘇

居多名刹如大

慈北禪乃東晉

㢩士戴顒故居

流水在人世武

陵豈無牛马神

仙江山清空義

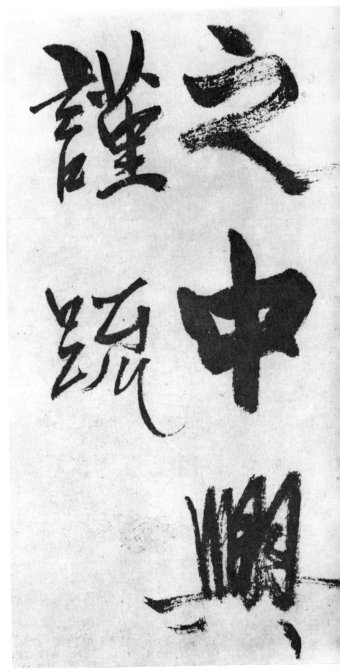

tery figure of this period.

Yang Wei Cheng 1277-1368

147

Wu Chun, 1298-1355

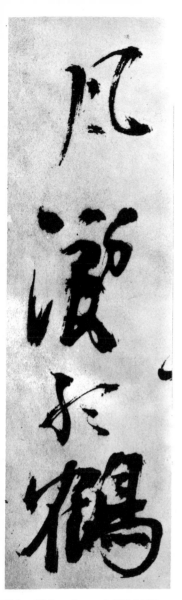

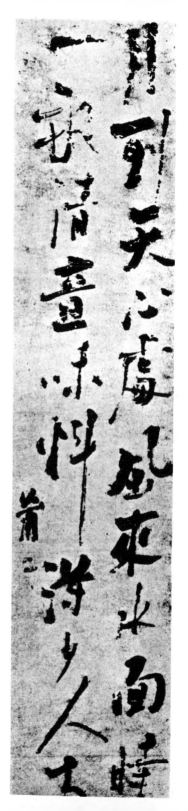

Ch'en Hsien-chang, 1428-1500
Used "weed-brush" which he made himself.

His brush strokes move like a frightened snake wriggling in water, or a thirsty steed dashing for the spring.

山閣坐談無俗
事清風滿面
作吟微夕陽
好在秋水外日
關遠山還未沉

沈周

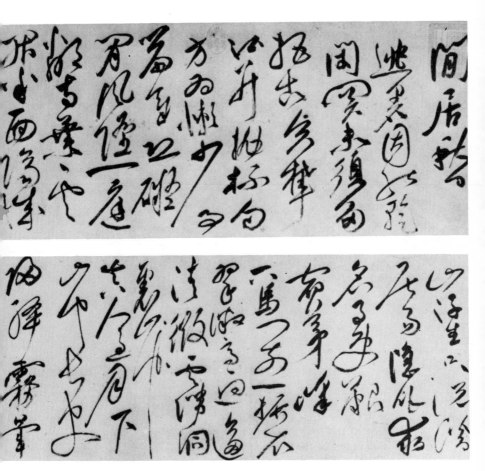

Chu Yün-ming 1460-1526
Born with an extra finger on his right hand, he was given
the nickname *chih shan* "branch hill". "As if without
thinking, he wrote with the dash and the impulse of a
child, an attitude that is decisively representative of his
uninhibited bohemian life." Ts'eng.Rated the best calli-
grapher of the Ming Dynasty.
T'ung Ch'i Chang said of his calligraphy: "Like steel
wrapped in cotton."

◀ Shen Chou 1427-1559

Wen Cheng Ming, 1470-1559
One of the four literary geniuses of the Ming Dynasty as
well as one of the four painters of talent.
Great friend of T'ang Yin, the painter. Extremely diligent,
he practised calligraphy every day. It is recorded that
having finished his daily practice of calligraphy one
morning, he laid down his brush and died with a faint
smile on his face.
Calligraphy characterised by a touch of daintiness &
effeminacy, but it evinces the high regard for propriety
and tradition of the writer.
His calligraphy is like a brook singing through a bamboo
grove.

祝希哲書蘭亭敘不下數本余所見惟朱性
甫孝廉石民望文學二君所藏為最佳今又
見此本全濟爭坐位帖而稍參以聖教序希
哲於古帖靡所不摹而又縱橫如意真書中
之聖也余見而心賞之特為補圖偶得趙松
雪畫卷精潤可愛故行筆設色一宗之不免
效顰之誚安能如希哲學書師心匠意前無
古人也嘉靖壬辰春二月廿五日徵明識

Wen Cheng Ming

153

交花時見流殘片莟
疑香隱家潑波吸哺
浪晚色滿紅雲何必
玄都觀山中自歲華

Wen Cheng Ming

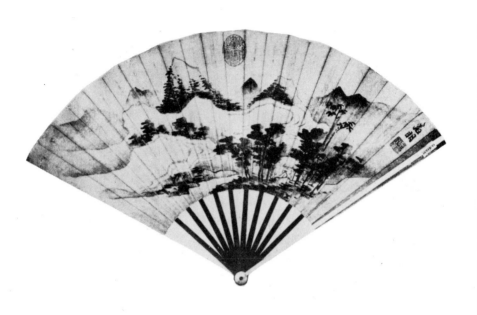

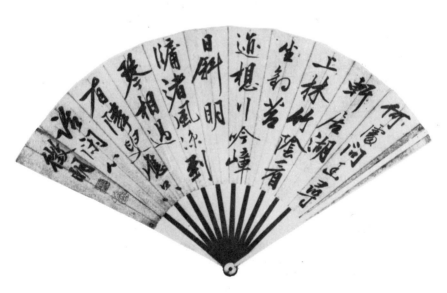

Wen Cheng Ming

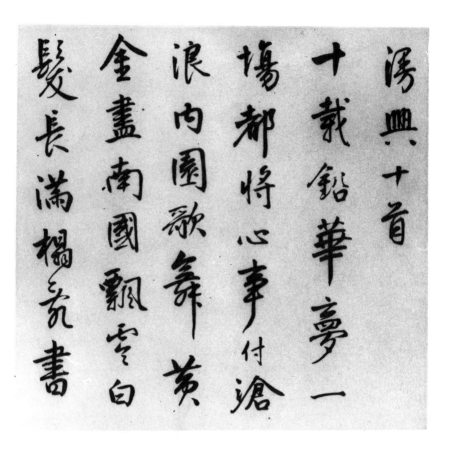

漫興 十首

十載鉛華夢一

場都將心事付滄

浪內園歌舞黃

金盡南國飄雲白

髮長滿楊〇〇書

T'ang Yin, 1470-1524
Greater as painter than as calligrapher: a colourful life often linked with romantic affairs but marred by a tragic involvement in a bribery case.
"Took after Chao Meng-fu but somewhat less robust."

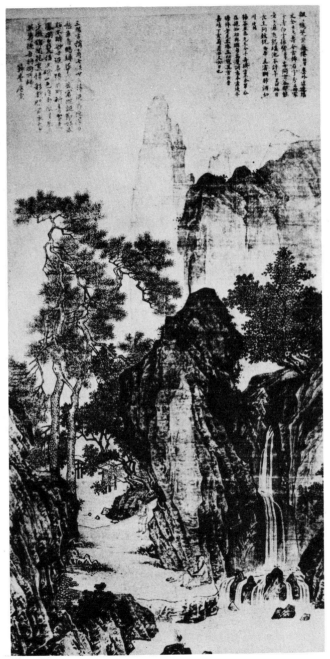

T'ang Yin

157

林軒窓兩過綠文加
山鵲摩飛噪晩
霞爛熳一番春夢
覺東風閒掃日夕
花夏木沱綠蔭濃
後峰鶯語催前
峰石床曲几閒調
貝倚畫浮雲三萬
重
辛卯五月王寵为
事茗書

Wang Ch'ung, 1494-1533

Blue and white vase of this period.

Wang Shou Jen, 1472-1528
Great scholar-soldier, considered one of the outstanding
thinkers of the Ming Dynasty.

158

兩子九月守仁頓

南贛之氣天日手而躍

寫公太岩曰樓吳公大

司宋蓬小勇公少司

故懷滓胜公抱昌梁

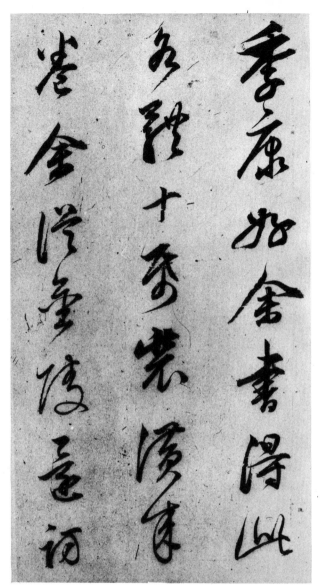

Tung Ch'i-ch'ang, 1555-1636
Equally well-known as a painter, he benefited enormously
by the art collection of Hsiang Yüan-pien, which brought
him on intimate terms with some of the greatest master-
pieces of all time. He first took as his model Yen
Chen-ching, then Yu Shih-nan, and then Wang Hsi Chih;
well-known for his "dry brush" technique.

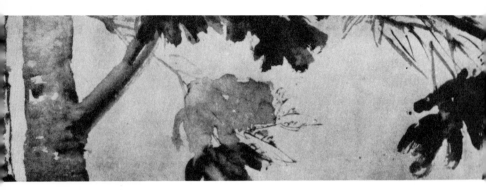

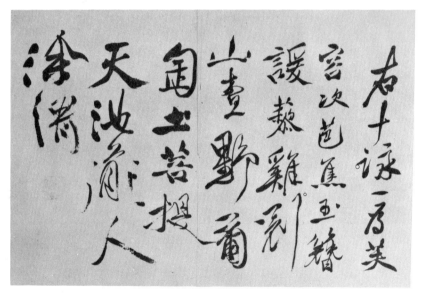

Hsu Wei, 1521-1593
His talent was not recognised in his life time and he led a
bizarre and erratic life. A great painter and drama writer.
His work has a sort of "nervous compulsion showing a man
without inner control" (Tseng)
Took after Mi Fei — wild and unbridled.

Specimens : pages 163-165

如聞海鳥東西

牲杰似山查便

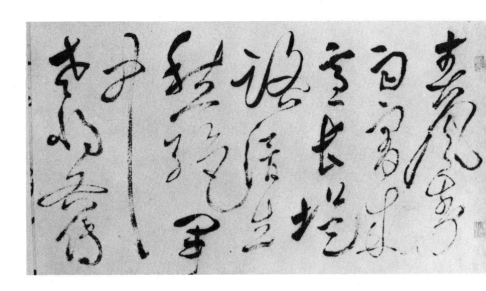

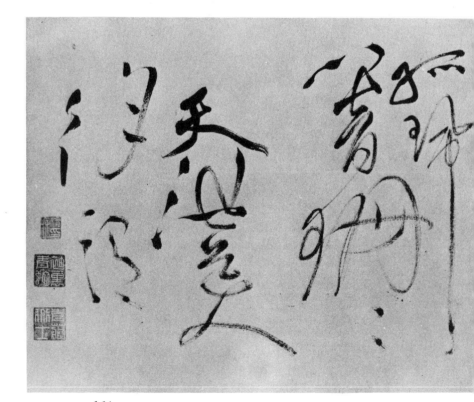

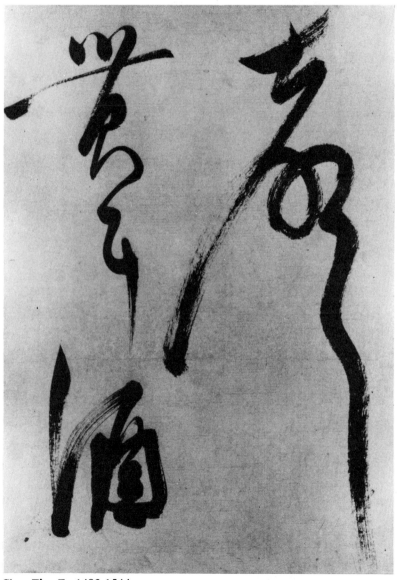

Chan T'ao Fu 1483-1544

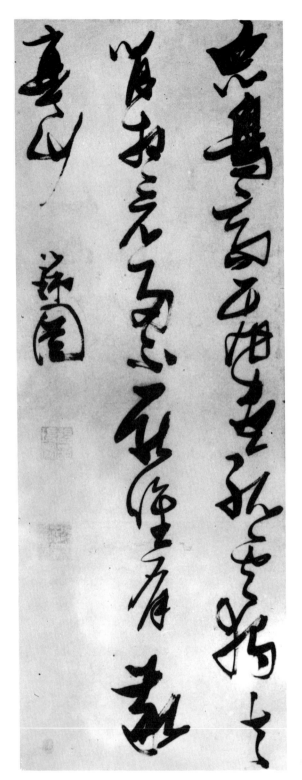

Blue and white Ming vase
of this period.

Ch'ang Jui-t'u, Cir. 1569-1644

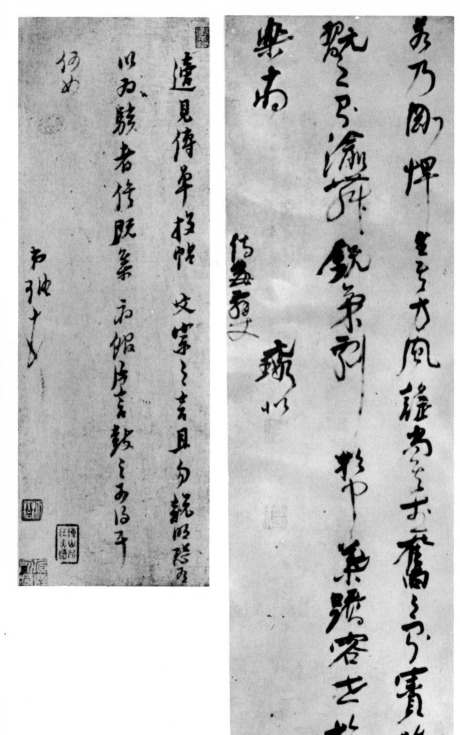

I Yüan Lo, 1593-1644

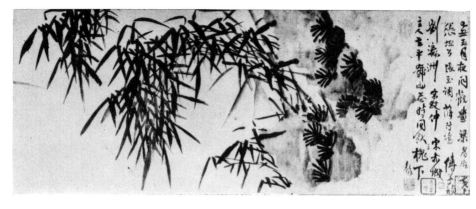

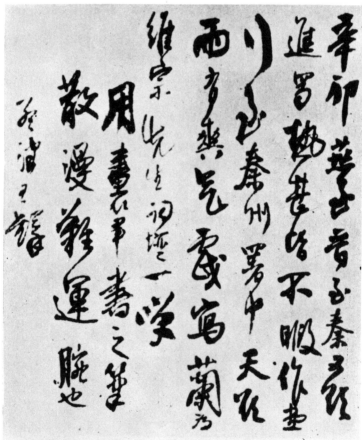

Wang To 1592-1652

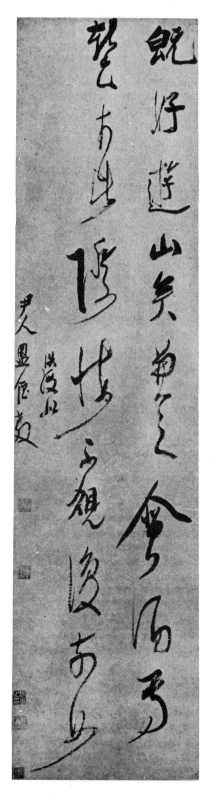

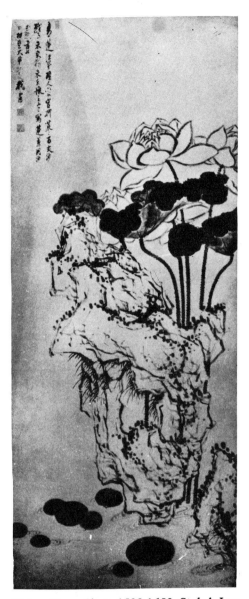

Ch'en Hung Shou 1599-1652 Styled Lao-
lien, "old lotus". Great painter:
Highly individualistic manner, probably
written with a long thin-tufted brush.

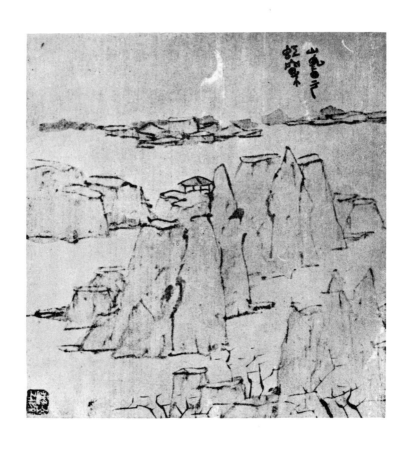

Fu Shan, 1607-1684

170

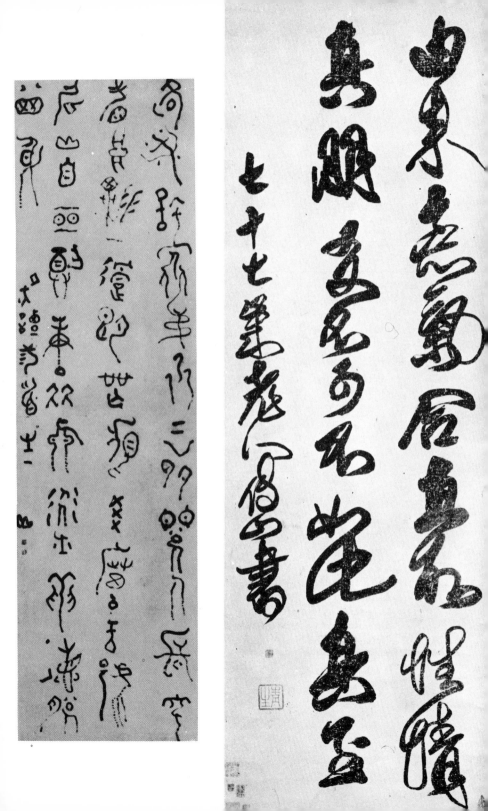

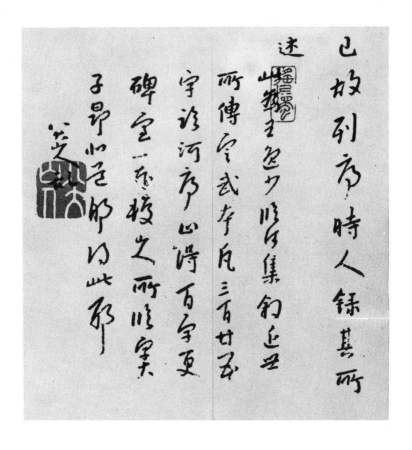

Chu Ta, (Pa-ta-shan-jen) C1625-C1705
A direct descendent of Emperor Tai-tsu, founder of the
Ming Dynasty. Entered monastery after the Dynasty colla-
psed. Refused to serve the new regime.
Pretended to be perpetually drunk. Better recognised as
painter. In calligraphy, he preferred to use a worn brush.
His calligraphy has the essence of the Ts'in and T'ang
styles.

172

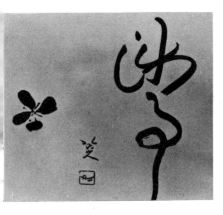

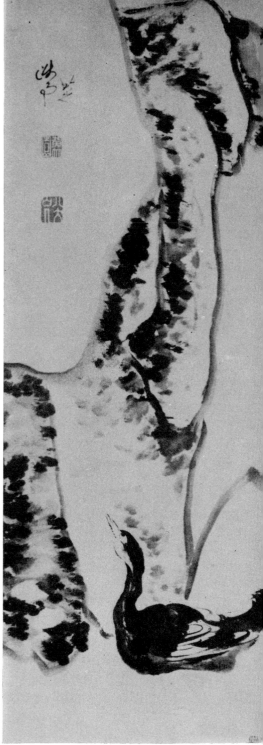

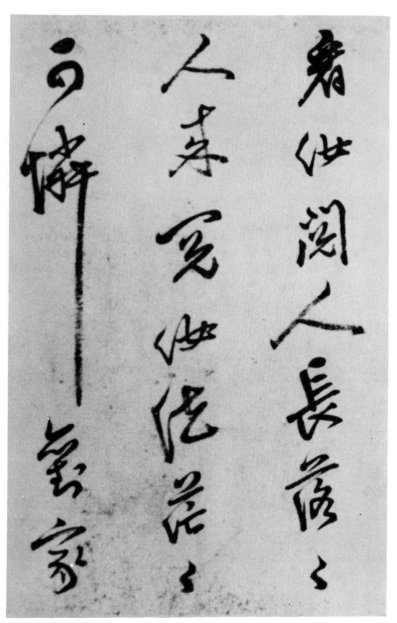

君世闊人長壽
人壽宽世促莙
可佛墨家

Chin Shih, better known as Tan Kwei, 1614-1680, was a
government official during the realm of Ch'ung Chen of
Ming Dynasty, after the fall of which he retired to become
a monk.

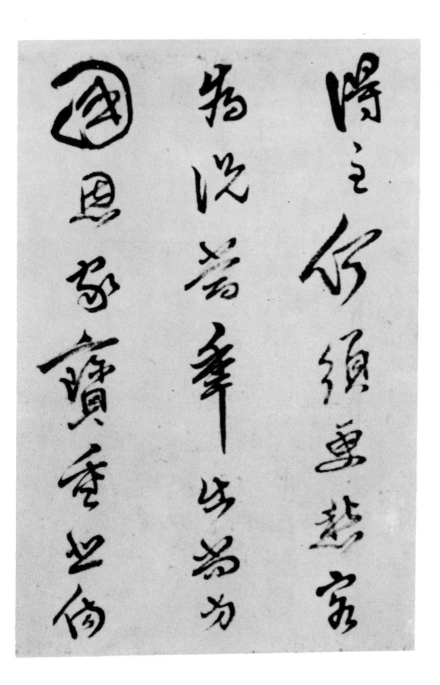

得之竹須勇慈家
為況善筆此為為
國且家寶秀世傳

175

雖有舟輿無所乘之雖有甲兵無所陳之使民復結
繩而用之甘其食美其服安其居樂其俗鄰國相望
雞狗之聲相聞民至老死不相往來
信言不美美言不信善者不辯辯者不善知者不
博博者不知聖人不積既以為人己愈有既以與人己
愈多天之道利而不害聖人之道為而不爭

Shih T'ao 1641-1707

176 A descendant of an elder brother of the first Emperor of
Ming; retired to become a monk.

177

Cheng Fu, 1622-1693
He took after the style of Han script.

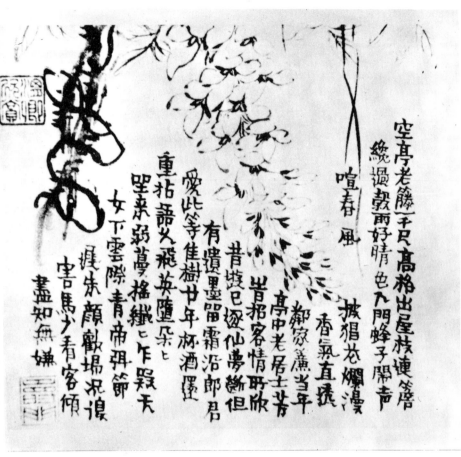

Chin Nung, 1687-1763
Pioneer of the movement to revive the art before the Tsin
& Tang; one of Eight Eccentrics of Yangchow (Yangchow
Pa Kuai)
An ardent student of ancient artifacts, his contribution to
calligraphy was to simulate on paper the characters he
found engraved on metal and stone, "even to the extent
of clipping off the tip of the brush to give it knife-like
qualities" — Chen. Calligraphy distinguished by angular
whimsical strokes; the brush probably held in a slanting
position.

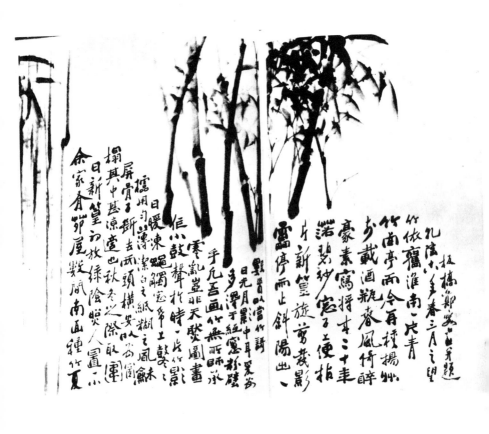

Cheng Hsieh, 1693-1765
Better known as Cheng Pan-ch'iao, one of the Eight
Eccentrics of Yangchow; poet, painter.
Mannerism very pronounced in his calligraphy; anti-
quarian, a combination of the *li* and *cursive scripts*.

(Note resemblance to Chuan Pao Tzu Pei, p. 60)

180

忽朕湖上片雲飛不覺

舟中雨濕衣拆得荷衣

渾忘却空將葑莕蓋頭

編

极稿居士以畫葉不知也
盒案知幾人學華境特矣耳
渴龍...菱...圈套不得或在此邊兩...
...鄭燮...

Porcelain vase of this period.

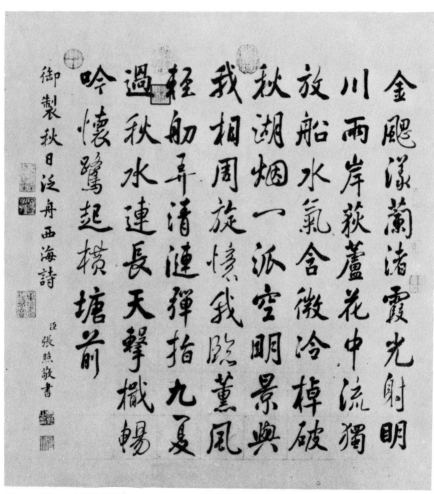

御製秋日泛舟西海詩　臣張照敬書

金颿漾蘭渚霞光射明川兩岸荻蘆花中流獨放船水氣含微冷棹破秋湖烟一派空明景興我相周旋憶我照薰風輕舠再清漣彈指九夏過秋水連長天擊檝暢吟懷鷺起橫塘前

Chang Chao, 1691-1745

182

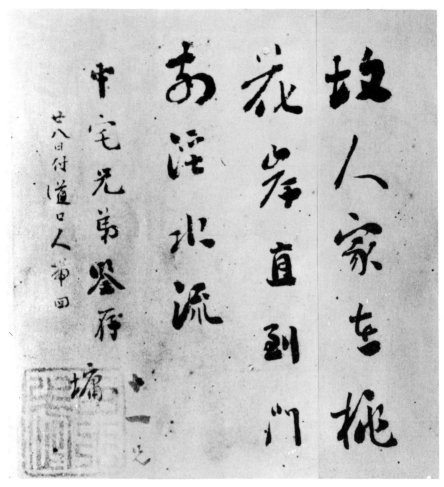

Liu Yung 1719-1804
Better known as Liu Shih-an. Scholar, philosopher and
courtier.

Teng Shih-ju, 1743-1805
Professional calligrapher, often regarded as one of the
greatest of the Ch'ing Dynasty calligraphers; avid student
of ancient artifacts, modelling after bronze and stone in-
scriptions.
K'ang Yu-wei once said: "Teng Shih-ju is to *chuan shu* as
Mencius is to Confucian philosophy."

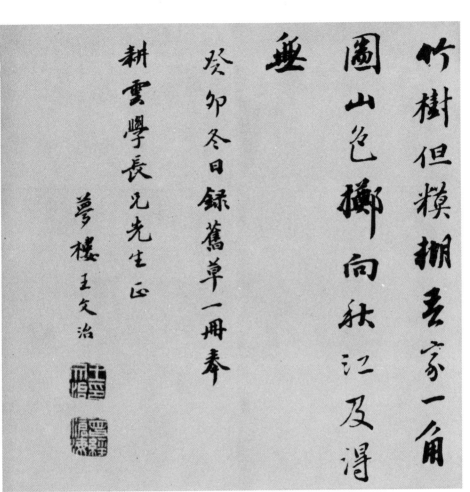

竹樹但糢棚吾家一角
圖山邑㮾向秋江及得
無
癸卯冬日錄舊草一冊奉
耕雲學長兄先生正
夢樓王文治

Wang Wen-chih 1730-1802
Calligraphy charming and "ladylike."

陰雲日堆積凉悄秋頻深苦雨不可

心我之瞎長林念此閒閒坐獨懷

日音橙桐欵窓戶暮輕憎涂沈今

我慶書卷廊嚴千古心家僮走

相振瑰華忽來晚成親王

[印][印]

Yung Hsing, 1752-1823, also known as Ch'eng Chin Wang
11th son of Emperor Kao-tsung of Ch'ing.

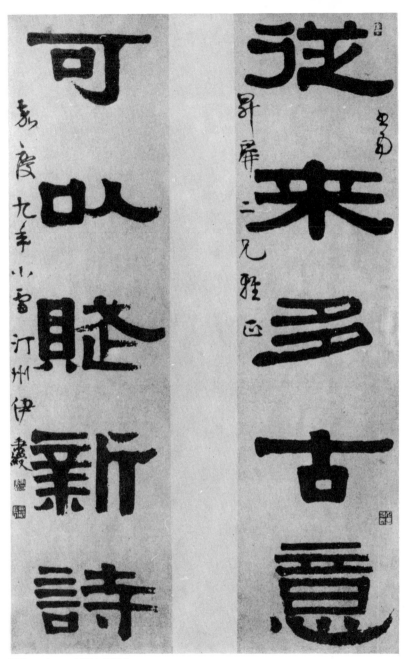

I Ping-shou, 1754-1815
He based his calligraphic style on the Northern Dynasties
stelae and was especially proficient in his *li* and *chuan*
scripts.

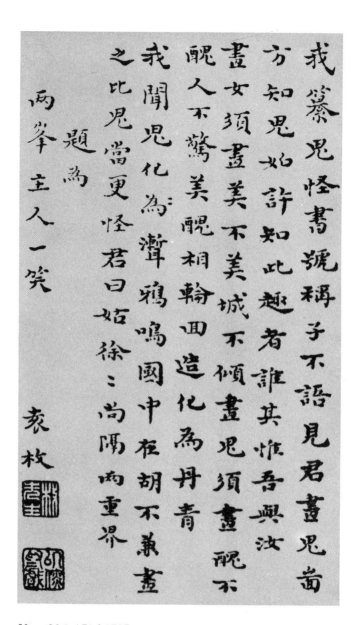

我纂鬼怪書號稱子不語見君畫鬼當
方知鬼始許如此趣者誰其惟吾興汝
畫女須畫美不美城不傾畫鬼須畫醜不
醜人不驚美醜相翰田造化為丹青
我聞鬼化為聲鴉鳴國中在胡不兼畫
之比兒當更怪君曰姑徐二尚隔兩重界

題為
兩峯主人一笑

袁枚

Yuan Mei, 1716-1797
Poet and man of letters. Noted for his epicurean way of
life.

Stem cup of this period.

Yao Nai, 1731-1815

秋館雲出草招條次窓盧楹一鑑
醫潘々未束花江面知為空瀬义
玉山時留書光雅證邪人林

Ho Shao-chi, 1799-1873

"With great internal control, his brush appears to have gone beyond his intent. It shows a slight arrogance — he let the ink drip in blots — and a lack of patience for detail" — Ch'en.

He describes his own method thus:

"When I write I always suspend my wrist, holding my brush with a strength that comes from my heel, travels through my body and appears from my finger-tips. The energy of my whole body is concentrated in the fingers, and then I move my brush. Not half finished, I would be soaking wet with sweat." — Tseng.

沙市舟中晚日入窗松

艳泛泓硯愛此金屑銑澤

因為郗直作卅　牧覽

去古人不遠　周子發下筆

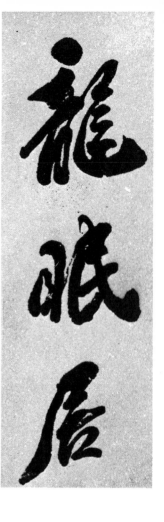

千里相思玉一枝
夜久雲寒魚老廉纖
庭院小坐送别面

蒼林

Pao Shih Chen 1775-1855

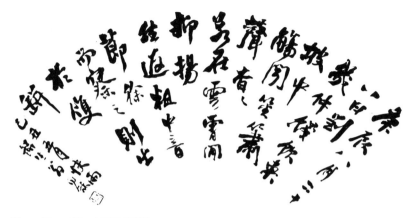

Yung Tung Ho, 1830-1904

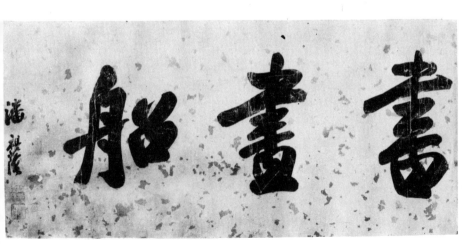

Pan Chü Yin, 1830-1890

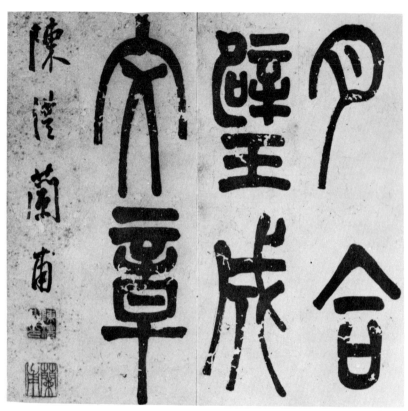

Ch'en Li, 1810-1882

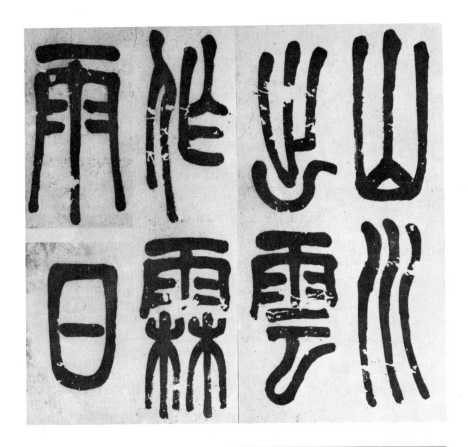

Decorated stem cup of this period.

浮自笑驅馳止如月東來西

去筆時促

悅西四兄大人屬

梅花盦詩為

撝叔 趙之謙

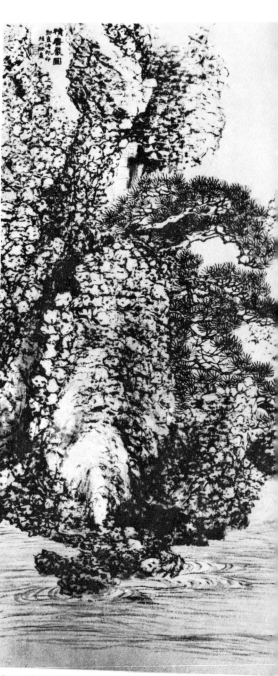

Chao Chih Ch'ien, 1829-1884

196

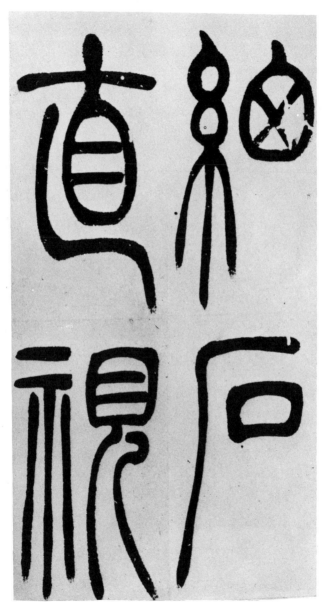

Wu Shih Tsai 1799-1870

K'ang Yu Wei, 1858-1927
Style original, but grotesque. Modelled after the Han and
Wei tablets.

198

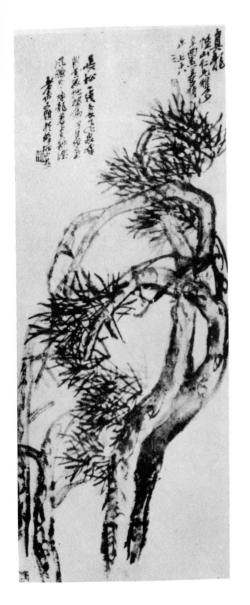

Wu Ch'ang Shih, 1844-1927
One of the great painters of Ch'ing Dynasty.
Well practised in the Stone Drum Script style.

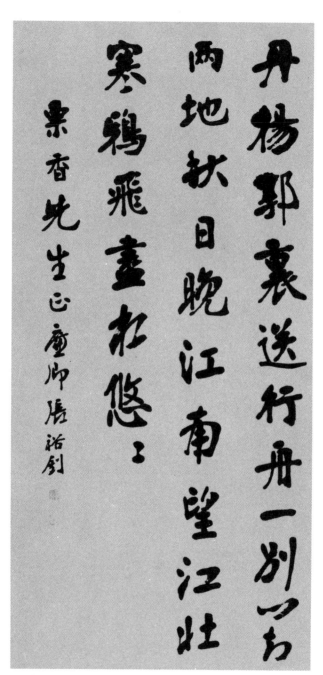

丹楊郭襄送行舟一別四時
兩地秋日晚江南望江北
寒鴉飛盡木悠悠

粟香先生正腕師張裕釗

Ch'ang Yü Chao, 1823-1894
He founded his calligraphic style on the stelae of the
Northern Dynasties.

繞屋疎林濃蔭綠軒窗都覺清幽
何當攜去一聲檻雲山烟水際倚檻懿
吟眸盡裹山排依峻嶺嵐光遠共雲
浮半江涼雨入新秋前汀橋影密彷
彿起漁謳　辛亥書日　曾國藩

Ts'eng Kuo Fan, 1811-1872
Statesman and soldier;
well known for his confrontation
with the Taiping rebels.

夫損之者如燈火之銷脂莫之見也而忽盡矣益者
如苗禾之播殖莫之覺也而忽茂焉故治身養性務
謹其細不可以小益為不平而不修不可以小損為
無傷而不防凡聚小所以就大積一所以至億也

文卿一兄大人政

庚午五月李文田

乾以定位山澤通氣雲行雨施既成萬物易之義也祀典
曰日月星辰所昭印也地理山川所生殖也功加於民祀
以勳之禮記曰天子祭天地及山川歲徧焉自三五迭興
其奉山川或在天子故在諸侯

拓本臨出舊藏揚州馬豐樓小玲瓏山館者也以華陰鄲縣兩本始知其僅屬明代拓耳
錬生三兄大人出金牋索作隸書因撫臨漢碑四通惟教正之己卯閏三月弟李文田

西嶽華山廟碑三本之說萌於翁覃谿而成於阮文達幾以為人間無復有第四本此洨北宋

Li Wen Tien 1834-1895

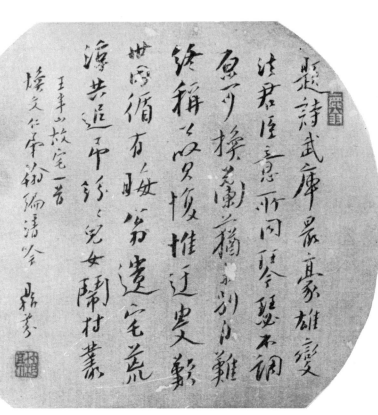

題詩武庫最豪雄 變法君臣意所同 歷今豎不調 魚可換蔑鞠所別自難 終稱故只負慚廷逞與繁 世時循有晚第遷宅荒 潭共逗市鈴兒女鬧村叢

壬辰以故宅一書 橋文仁年翰編清吟 鼎芬

Liang T'ing Fen, 1859-1919
His calligraphy shows an extremely individualistic style;
late Ch'ing Dynasty scholar.

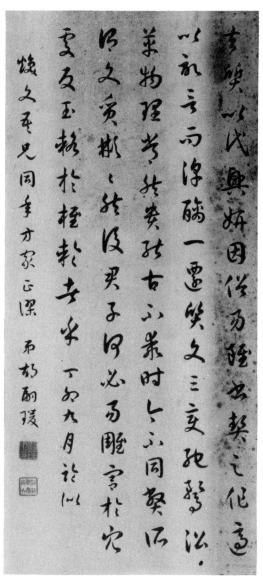

Hu Szu Yuan, fl. 1910

FORMAL SCRIPT

The four specimens that follow are characterised by their ▶ extremely fine & delicate lines, faultlessly executed — a distinct advantage at the imperial court examination.

文王在上於昭于天本支百世其麗不億厥作吁近

周雖舊邦其命維新凡周之士有商孫子裸將於京

有周不顯帝命不時不顯亦世上假哉天殷士膚敏

文王陟降在帝左右厥猶翼翼於絹熙敬天命靡常

娓娓文王令聞不巳思皇多士文王以寧侯於周服

陳錫哉周侯文王孫子此王國濟濟多士上帝既命

Ch'ang Chien Hsün, Fl. 1920
Chuang Yuan 1889 Court Examination.

直哉史魚邦有道如矢

表衛大夫之直可先驗諸有道時焉夫史魚者衛之

直臣而未遇乎有道時者也夫子欲備言其直故先

以有道如矢稱之曰吾聞主聖則臣直此聖明之代

所以獨著君臣一德之休也然緬懷忠直者又往往

謂世當隆盛而其節不彰豈知諫諍為懷尚論者要

Ch'en Po-t'ao, 1855-1930
T'en Hua, 1892 Court Examination.

大唐王居士塼塔之銘　上官靈芝製文　敬客書

居士諱公字孝寬太原晉陽人也英宗賴邁遠胄隆

周茂緒遐昌爵冠後魏樂府歌其載德天下挹其家

聲具詳畐牒豈煩觀縷居士早摽先覺本遺名利遍

覽典墳備窮義窟觀老莊如糟粕視孔墨猶灰塵得

給園之說鏧求彼岸之路勵精七覺仰十地而翹勤

Tsang Kwang Chun, Fl. 1920
Hanlin 1889 Court Examination.

輕如蟬翼細蠅頭百鍊剛為繞指柔蜀狗只今成棄物雕

蟲豈免壯夫羞巢痕天上掃無餘爭說儂家只步虛誰

信殘膏雞犬舐幾多平步到丹除幾人青史幾黃泉師

友平生具此編尚有江西朱少保曾扶寒日出雲淵登

朝自愧進諸老晚值　經帷感鬢華日寫赫蹏觀奏

進被人嗤點陳薑芽

乙丑丙寅隨扈行在日進講義初亦用白

摺書繕呈然目眊手僵大異昔時矣

Wen Su 1879-1939 A.D.
Hanlin 1889 Court Examination.

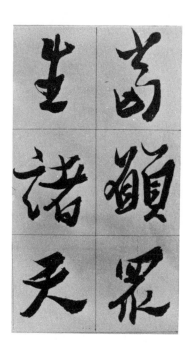

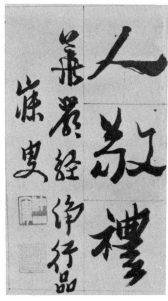

Shen Mei Sou, 1850-1922

Cheng Shao Su 1860-1938

卧薪苦欲求同志寢戈無望

來驕帥替師夜：治軍書警

枕摩挲長不寐一夕卧沈：醉

覆被慈宮傷往事夢中應去

尋先帝一卧醒潛：滿榻前有

Wu Tao Yung, 1857-1936

以乘和競讓徵人世之德怨
以勤惰奢約兆人家之成敗
以盈損眷肆卜人世之吉凶
以仁劉孚薄推人福之悠傖
譬如沱薯求爵循穴搜鼠鼾
肴失者矣
右作齋恥言一則丁外長夏
荔垞書示怙昌兒恊誦

Lai Chi Hsi, 1864-1937
The specimen is characterised by its resemblance to Chu
Shu Liang's calligraphy.

211

安定王俛為太
妃敬造石窟一
驅依巖泉崇
沖妙鸛靈像相
叢工續

方重禹洛派
之正宗 胡[印]

Hu Hsiao Shih, 1887-1962

Jü Yu Jen 1878-1965

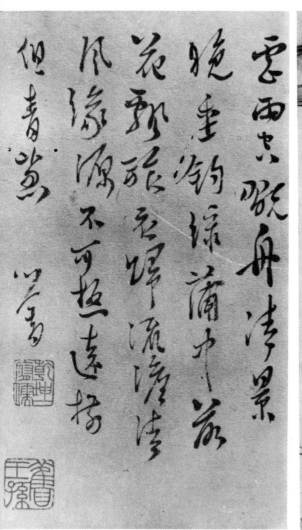

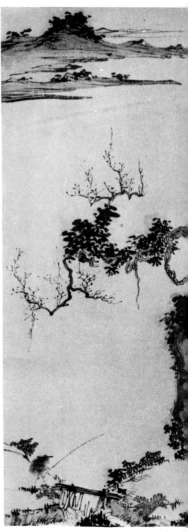

Pu Hsin Yü, 1896-1963

Pu Hsin Yü

Lin Chih M'ien, 1898-1944
A loyal follower of Sun Yat Sen during the Revolution, he was often thrown into prison, where he perfected his calligraphic style.

Shen Yin Mo 1882-1967 (?)

綠蕪蔽徑晚蛙鳴臥聽雲鳥聲
松竹洞僊窩冬農家遍通新坯
滑澄路夕照斜陽半倚窗依
明月上難色華蒼古鷹暑晚煙

抗戰日唐儒州六筆詩句
孫生貴秋同上賢六紀龕

Mo Chi P'eng 1885-1972.

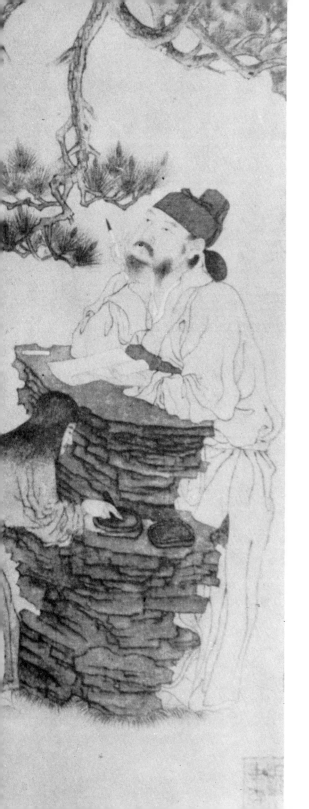

Appendices

217

関杷梓森羅琳瑯瑩彩筆雲霽露之健

筆吞政吐鳳之年又顏謝可以執鞭應

徐自然街壁下官栖遑失路懷抱沈愁頓

辟野鶴之羣来劇真龍之友不期而會

其中群旅之心握手言難更切依然之思乎

時風雨如晦花柳含春雕梁肅栗興雙

飛喬木聽黃鴬兼轉故更別思

Section of Obotsu Shijo (foreword to the poems of Wang Po). 707

欲　至　賑　共　諸　五　勸　今
與　於　明　相　藝　百　力　明
太　力　智　謂　皆　童　時　各
子　振　慧　言　通　子　挽　開
挍　詘　善　太　名　既　鋬　俊
其　勝　解　子　徹　聞　達　藝
勇　我　書　雖　十　太　多　有
健　等　論　漠　方　子　菁　大

The Search for Buddha Anon. c. 729-749
A copy of a 6th century Chinese scroll. The text refers to the colloquy between Buddha and the messenger whom his father had sent to recall him from a life of austerity.

爾時太子年至十歲
諸釋種中五百童子
皆亦同年太子從弟
提婆達多次名難陀
次名孫陀羅陀等或
有卅相卅一相者或
復雖有卅二相相不

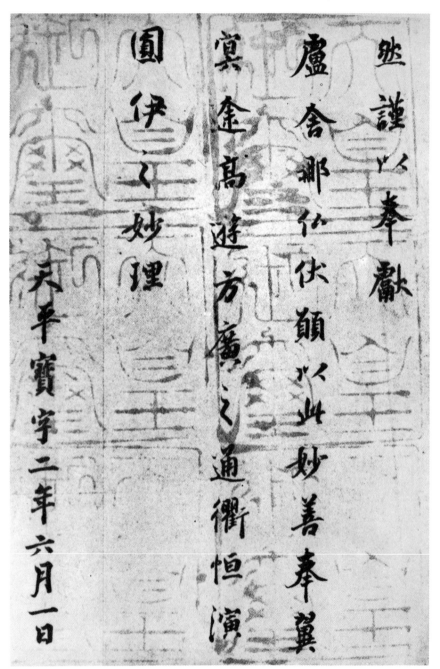

然謹以奉獻

盧舍那仏伏願以此妙善奉翼

冥途高遊方廣之通衢恒演

圓伊之妙理

天平寶字二年六月一日

Anon. 758. Section of Daisho O Shinseki Cho.

222

虚室重招尋忘言契斷金
英浮漢家酒雪麗先王琴
虞匋稱壽養為臺晚吹嶺
徐何聽權秀詐肯訪仙
陰會

Emperor Saga 9th century. Fragment of a poem by
Li Chiao

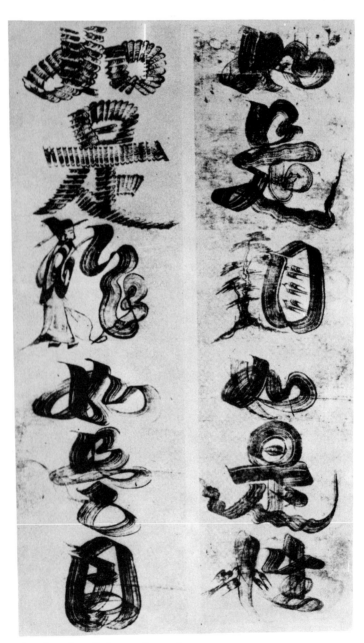

Attributed to Kukai, early ninth century.
Section of Ju Nyoze.

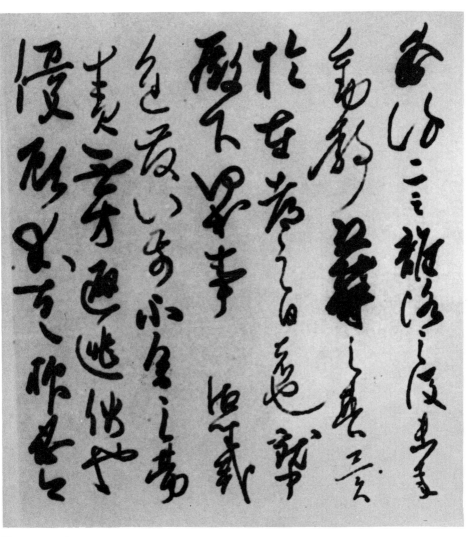

Fujiwara Sukemasa, 991.

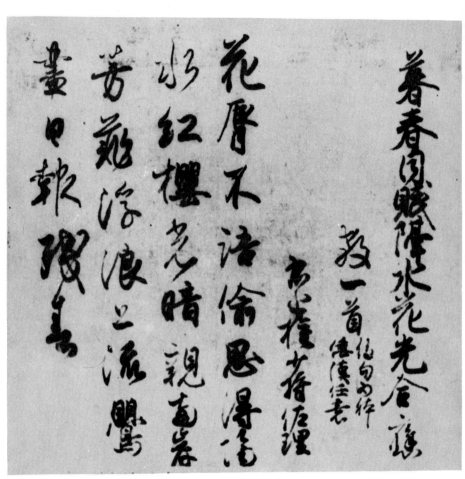

Fujiwara Sukemasa, 966-69.

226

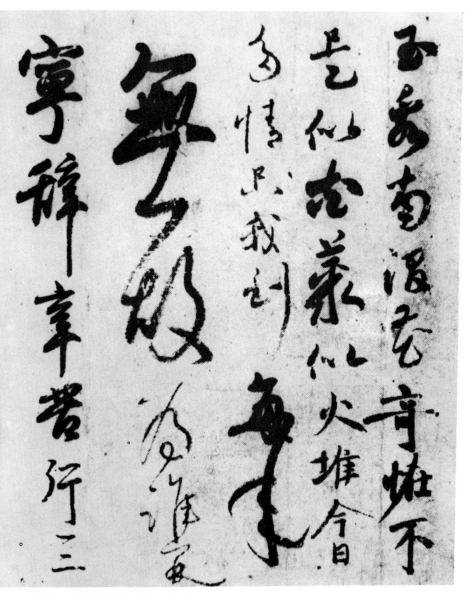

Fujiwara Yukinari, 1020. Section of a letter

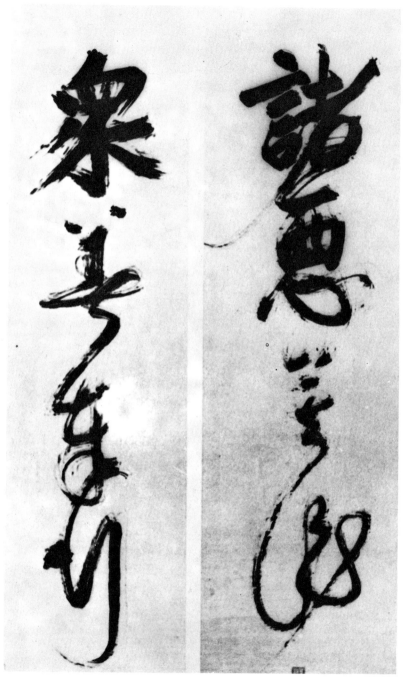

Ikkyu Sojun, 15th century. Section of Buddhist Verse

228

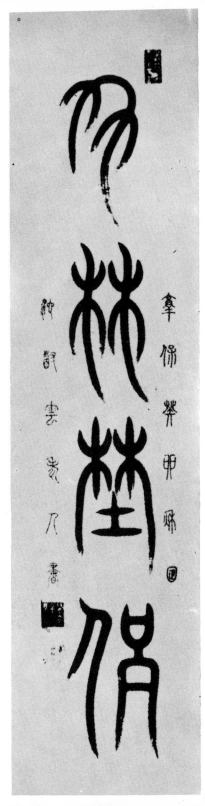

Tensho by Ikenageo Doun, 1723.

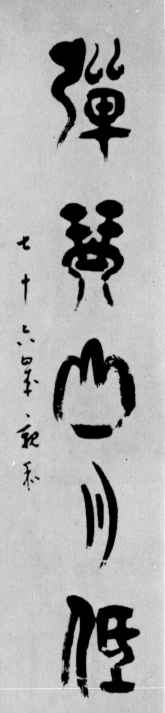

Tensho by Mitsui Shinna, 1775

Ike no Taigo. Late 18th century. Poem by Wang Wei, T'ang poet.

獨茧鱼货之高潭
柔汝长啸泛康人
不与明月其去过

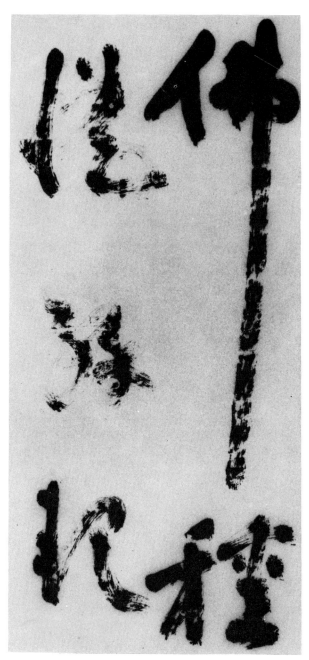

Buddhist maxim by Jium. Late 18th century.

Ways of Holding the Brush

What is the best way of holding the brush?The question has long been a subject of debate. The four photographs on P. 234 demonstrate the ways advocated by various calligraphers; the pictures on 235-6 show yet other variations. Each artist may have his own particular way of doing it, which may be peculiarly suitable for certain scripts and styles of writing. In any case, the brush should be held firmly whether in an upright or slanting position, depending on the artist's requirements. For freedom of movement, the hand, the wrist and the arm itself should be lifted above the surface of the desk when writing. For the writing of small characters, this is not generally practicable although Mi Fei, the Sung calligrapher, was well-known for his ability in this respect. There should be little difficulty with large characters of, say, over 1 inch.

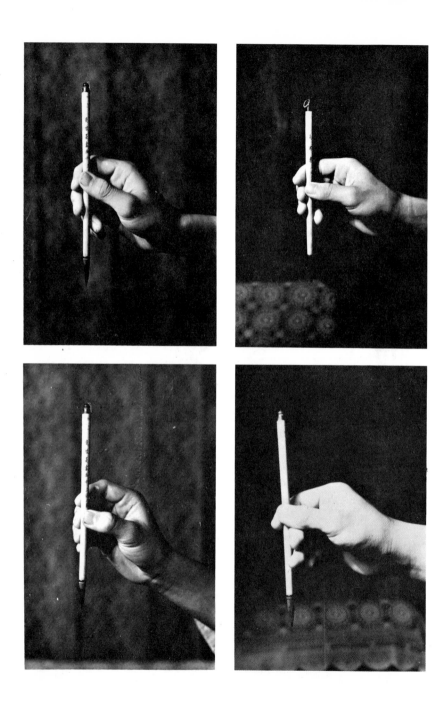

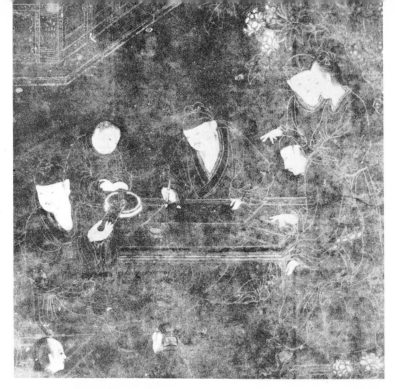

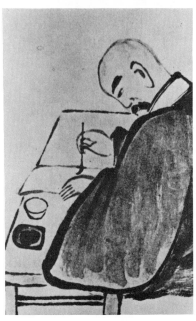

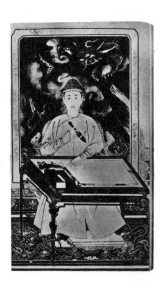

Upper: from a stone rubbing.
Lower left: Ch'i Pai Shih's painting "Shih Tao"
Lower right: Emperor Chien Lung

235

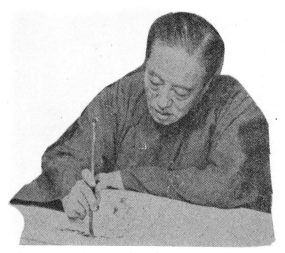

Pu Hsin Yu (1896-1963)

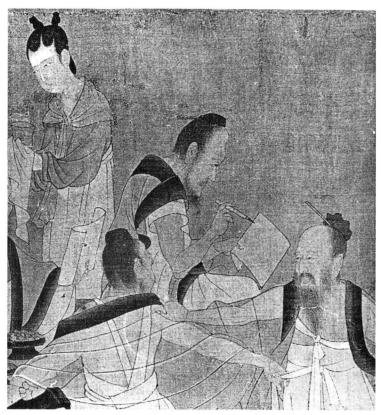

From a 7th century painting

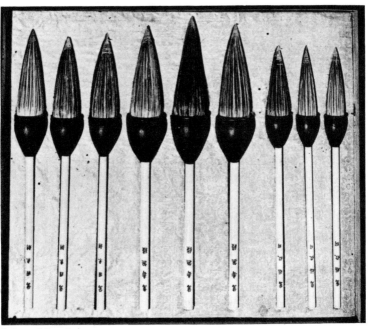

Ink and Brushes

Inkstone/Brush-washes

Papers weight/Ink-pad container

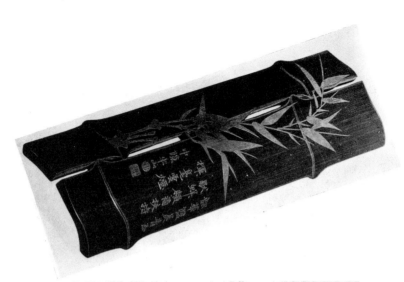

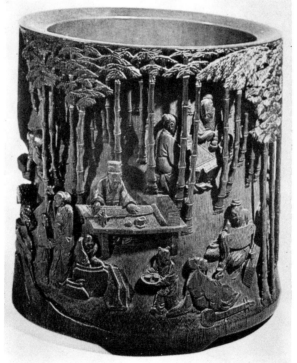

Armrest/Brush-holder

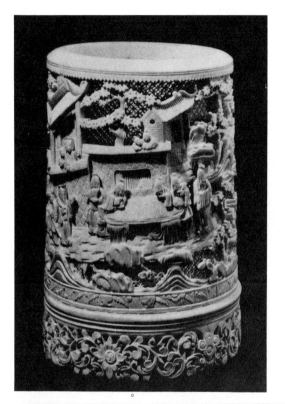

Brush-holder/Brush-wash

Variations

Variations

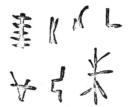

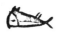

Neolithic signs circa 4,000 B.C. discovered near Sian

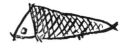

Neolithic Symbols	"Lung Shan" Symbols	Oracle Bone Script Shang Dynasty	Bronze Script Shang Dynasty
∣	∣	∣	∣
✝	✝	✝	✝
Ɛ	E	Ɛ	Ɛ
↑	⌃	↑	⊦
✕	✕	X̆	X̆
↑	⌃		↑

SELECTED APHORISMS ON CHINESE CALLIGRAPHY

I was fifteen when I first paid attention to calligraphy. The artistry of Chung Yu and Chang Chih fascinated me; I also took Wang Hsi Chih and his son as my models. I have by now studied them assiduously for over twenty four years. Calligraphy of a high order of excellence evoke exquisite sensations of the mind. That is why certain strokes are given special names such as: *dew poised on a needle point; stones hurling down from thunderous clouds above; queen-swans in majestic flight; animals in startled stare; a phoenix in splendid dance; a surprised snake in steely recoil; peaks tumbling down a precipice; a man dangling over a cliff holding onto a dried branch.* Sometimes a stroke may look heavy like dark hanging clouds; sometimes as light as a cicada's wings. Sometimes a light tilting of the tip of the brush makes a stroke flow like a spring; or a deliberate "stay" of the brush gives another stroke the preponderance of a mountain. Sometimes its delicate beauty reminds one of the new moon emerging from the horizon; sometimes it is resplendent like an array of stars in the sky. Only nature can create such beauty, not man. The exquisite blending of wit and craftmanship! Heart and hand in perfect co-ordination. All this is worked through the tip of the brush — each stroke endowed with varied rhythm, each dot with subtle resilience.

Sun Chien Li. *Su Pu*

A rock should contain elements of *"flying-white"*;
A tree should be composed of *"seal"* strokes;
Bamboo leaves are best done with the *"pa-fen"* method;
When this is thoroughly understood,
It will be found that calligraphy and painting are one and the
same thing.

Chao Meng Fu

There is nothing more difficult than modelling after an ancient artist. One should first think about him and his changing moods; then take into consideration the time and place of the composition to be modelled upon and then try to write in his manner. Only in this way can one cultivate maturity of mind and emotion and achieve empathy with the calligrapher. If one neglects this but only aims at superficial similitude, he is not worth discussing with.

Chiang Chi: *Chu Shu Pu Lun*

The Art of Calligraphy is a form of recreation in which one unburdens one's heart and soul, dissipates care and gets rid of melancholy. Preoccupation with trivial affairs precludes one from writing well although one may use a brush made of the best rabbit's hair. To start, one must first sit down quietly and meditate, take up the brush and write according to one's mood. One must not engage in conversation. The mind should not wander but be intent, as if having an audience with one's sovereign. This is the way to fine work.

Ts'ai Yung: *Pi Lun*

Chang Hsü of old was skilled in the cursive script, to the exclusion of others. He was able to express his every emotion in it: pleasure, anger, embarrassment, sadness, pity, buoyancy, regret, grievance, admiration, yearning, insobriety, indignation, ennui – anything he felt he expressed in his cursive script. Moreover things he observed were also a source of inspiration: the landscape, birds and animals, vegetation, the sun, moon and stars, wind and rain, fire and water, thunder, battle dance and song, and all changes of nature and events that brought gladness or surprise – all this he records in his calligraphy. That is why Chang Hsü's art has such miraculous variety, but it defies understanding

Han Yu: *To The Reverand Kao Hsien*

The paper is the battle field;
The brush is swords and spears;
The ink is the hood and armour;
The inkstone is the wall and moat;
The mind is the Field-marshal;
Craftsmanship is the lieutenents;
Composition is strategy;
Lifting of the brush determines the battle's fate;
The ins-and-outs of the brush are the Field-marshal's orders;
The twists and bends are the killings.

Wang Hsi-chih: *Madam Wei's*
Calligraphic Strategy

246

GLOSSARY

Anyang	安陽
Chang Chao	張照
Chang Chi Chih	張即之
Chang Chien Hsün	張建勳
Chang Ch'ien Mu Chih	張儉墓誌
Chang Hei Nü Mu Chih	張黑女墓誌
Chang Hsü	張旭
Chang Jui-t'u	張瑞圖
Chang Meng Lung Pei	張猛龍碑
Chang Ts'ao	章草
Chang Yü	張雨
Chang Yü Chao	張裕釗
Chao Chih Ch'ien	趙之謙
Chao Meng-fu	趙孟頫
Ch'en Chih-mai	陳之邁
Ch'en Hsien-chang	陳獻章
Ch'en Hung Shou	陳洪綬
Ch'en Li	陳澧
Ch'en Po-t'ao	陳伯陶
Chen Shu	眞書
Cheng Ch'ang Yu Tsao Hsiang	鄭長猷造像
Chêng Ch'i Ko	正氣歌
Cheng Fu	鄭蕙
Cheng Hsieh (Cheng Pan-ch'iao)	鄭燮
Cheng Pan Ch'iao	鄭板橋
Cheng Hsiao Hsü	鄭孝胥
Cheng Tao Chao	鄭道昭
Chi Chiu Chang	急就章
Chi-ling Sung	鴿鴒頌
Chia Liang Ming	嘉量銘
Chih Shih Tieh	積時帖
Chih Yung	智永
Chin Nung	金農
Chin Shih	金釋
Ch'ing Dynasty	清
Ch'ing Lung Kuan Sung Ming	清龍觀頌銘
Chiu Hua T'ieh	韮花帖
Ch'iu Ying	仇英
Chu Hao	崔灝
Chu Hsi	朱熹
Chu I Chang	朱義章

Ch'u Sui Liang	褚遂良
Chu Ta (Pa-ta-shan-jen)	朱耷（八大山人）
Chu Yü-ming	祝允明
Chuan Shu	篆書
Chuang Yüan	狀元
Chung Shao-ching	鍾紹京
Chung Yu (Chung Yao)	鍾繇
Eight Eccentrics of Yangchow	楊州八怪
Fei pai	飛白
Fei Shao Chen	斐守眞
Four Creature Mirror	四獸鏡
Fu Shan	傅山
Han Bamboo Script	漢竹簡
Hanlin	翰林
Ho Shao Chi	何紹基
Hsi Ping Shih Ching	熹平石經
Hsi Yüeh Hua Shan Miao Pei	西嶽華山廟碑
Hsiang Yüan-pien	項元汴
Hsiao Chuan	小篆
Hsiao I	蕭翼
Hsiao Yen	蕭衍
Hsü Hao	徐浩
Hsu Pei-hung	徐悲鴻
Hsü Wei	徐渭
Hsuan-tsung	唐玄宗
Hu Hsiao Shih	胡小石
Huai Jen	懷仁
Huai-su	懷素
Huang Ti	黃帝
Huang T'ing Chien	黃庭堅
Huang T'ing Ching	黃庭經
Hui-tsung, Emperor	宋徽宗
I Ho Ming	瘞鶴銘
I Ping Shou	伊秉綬
I Shan Pei	嶧山碑
I Ying Pei	乙瑛碑
I Yüan Lu	倪元潞
Jü Yu Jen	于右任
K'ai shu	楷書
K'ang Yu-wei	康有爲
Kao Hsien, Monk	高閑（僧）
Kao-tsung, Emperor	宋高宗

Pan Ch'ü Yin	潘祖蔭
Pan-p'o	半坡
Pao Shih Chen	包世臣
Po Chü-i	白居易
Pien Ts'ai	辯才
P'ing Fu T'ieh	平復帖
Pu Hsin Yü	傅心畬
Pu Kung Ho Hsiang Pei	不空和尚碑
San Shih P'an	散氏盤
Shen Chou	沈周
Shen Yin Mo	沈尹默
Sheng Chiao Hsü	聖敎序
Sheng Hsien T'ai Tzu Pei	昇仙太子碑
Shih Ch'en Pei	史晨碑
Shih Huang Ti	始皇帝
Shih Ku Wen	石鼓文
Shih Men Ming	石門銘
Shih Men Sung	石門頌
Shih Ping Shih Ching	熹平石經
Shih Ping T'ai Pei	始平台碑
Shih Sung Kuei	史頌簋
Shih T'ao	石濤
Shu Hua Chuan	書畫船
Shu Pu	書譜
Su Ché	蘇轍
Su Shih (Su Tung Po)	蘇軾（蘇東坡）
Sui Dynasty	隋
Sun Ch'ien Li	孫虔禮
Sung Shan K'ai Mu Miao Shih Ch'ueh Ming	嵩山開母廟石室闕銘
Sung Shan Shao Shih Shih Chüeh Ming	嵩山少石室闕銘
Szu Ma Kuang	司馬光
Ta chuan	大篆
T'ai Shan	泰山
T'ai Shan Chin Kang Ching	泰山金剛經
Tai Shan K'ê Shih	泰山刻石
T'ai-tsu	太祖
T'ai-tsung, Emperor	唐太宗
Tan Kwei	澹歸
T'ang Hsuan-tsung	唐玄宗

250

T'ang Yin	唐寅
T'ao Hung Ching	陶弘景
Tao Yin Fa Shih Pei	道因法師碑
Teng Shih-ju	鄧石如
Thousand-character Essay	千字文
Tiao Pi Kan Wen	弔比干文
Ts'ai Hsiang	蔡襄
T'sai Yung	蔡邕
Ts'ang Chieh	倉頡
Tsang Kwang Chun	曾廣鈞
Ts'ao Chüan Pei	曹全碑
Ts'ao Shu	草書
Ts'eng Kuo Fan	曾國藩
Tsin	晉
Tsu Shu T'ieh	自述帖
Ts'uan Lung Yen Pei	爨龍顏碑
Ts'üan Pao Tzu Chuan	爨寶子傳
Tu Fu	杜甫
Tung Ch'i-ch'ang	董其昌
Wang An Shih	王安石
Wang Ch'ung	王寵
Wang Hsi Chih	王羲之
Wang Hsien Chih	王獻之
Wang Shou Jen	王守仁
Wang To	王鐸
Wang Wei	王維
Wang Wen-chih	王文治
Wang Yang Ming	王陽明
Wang Yüan	王遠
Wen Cheng Ming	文徵明
Wen Su	溫肅
Wen Ti'en Hsiang	文天祥
Wu Ch'ang Shih	吳昌碩
Wu Chü	吳琚
Wu Chun	吳叡
Wu Liang Ancestral Hall Stele	武梁詞碑
Wu Tao Yung	吳道鎔
Wu Tse T'ien, Empress	武后則天
Wu Yüeh	吳說
Yang Meng Wen	楊孟文
Yang Ning-shih	楊凝式
Yang Ta Yen Tsao Hsiang	楊大眼造像

Yang Wei Cheng	楊維楨
Yao Nai	姚鼐
Yeh Kung Ch'o	葉恭綽
Yen Chen Ch'ing	顏眞卿
Yen Shih Bronze Basin	嚴氏銅洗
Yu Shih Basin	萬氏洗
Yü Shih-nan	虞世南
Yü Yu Jen	于右任
Yuan Mei	袁枚
Yüeh Fei	岳飛
Yung Hsing (Ch'eng Chin Wang)	永瑆　（成親王）
Yung Tung Ho	翁同龢

LIBRARY
FLORISSANT VALLEY COMMUNITY COLLEGE
ST. LOUIS, MO.

INVENTORY 1983